TOP TRAVEL PHOTO TIPS

FROM TEN PRO PHOTOGRAPHERS

A QUICK-AND-EASY EVERYDAY PHOTOGRAPHY GUIDE™

CHUCK DELANEY

ALLWORTH PRESS
NEW YORK

Special Thanks to the ten distinguished photographers who gave us permission to interview them for this book and reprint their amazing travel images. Each photographer holds all rights to her or his respective photographs.

Front Cover Image © **Marc Muench**
Back Cover Images (top to bottom) © **Chase Guttman,**
© **Peter Guttman,** © **Michael Doven, and** © **Larry Louie**

Michael Doven (pages 12 to 21) Michael's picture © Alex Lake
www.michaeldoven.com
Wendy Connett (pages 22 to 31) Wendy's picture © Esteban Lartigau
www.wendyconnett.com and escapenewyork.blogspot.com
Larry Louie (pages 32 to 41) Larry's picture © Joanna Wong-Louie
www.larrylouie.com
Chase Guttman (pages 42 to 51) Chase's picture © Peter Guttman
www.chaseguttman.com
Mitchell Kanashkevich (pages 52 to 61)
www.mitchellkphotos.com and www.mitchellkphotos.com/blog
Marc Muench (pages 62 to 70) Marc's picture © Andy Williams
www.muenchphotography.com
Nadia Shira Cohen (pages 72 to 81) Nadia's picture © Paulo Siqueira
www.nadiashiracohen.com
Tom Robinson (pages 82 to 91)
www.tomrobinsonphotography.com
Jesse Kalisher (pages 92 to 101) Jesse's picture © David Winton
www.kalisher.com and www.kalisher.com/photo_blog
Peter Guttman (pages 102 to 111) Peter's picture © Peter Guttman
www.peterguttman.com

© 2012 New York Institute of Photography

12 13 14 15 16 17 18 19 20 21 10 9 8 7 6 5 4 3 2 1

Published by Allworth Press
An imprint of Skyhorse Publishing, Inc.
307 West 36th Street, 11th Floor
New York, NY 10018
www.skyhorsepublishing.com and www.allworth.com

Copublished by New York Institute of Photography
New York Institute of Photography is a registered trademark of
Distance Education Co. LLC in the United States and/or other countries
211 East 43rd Street, Suite 2402
New York, NY 10017
www.nyip.com, blog.nyip.com, and www.decnyc.com

Covers and Interior Page Design by Keith Gallagher
Editorial Writing by Sarah Van Arsdale
NYIP Publisher: Jay Johnson
NYIP Director: Chuck DeLaney

Library of Congress Cataloging-in-Publication Data has been applied for and is on file with the Publisher.

ISBN: 978-1-58115-995-0
Printed in China.

Contents

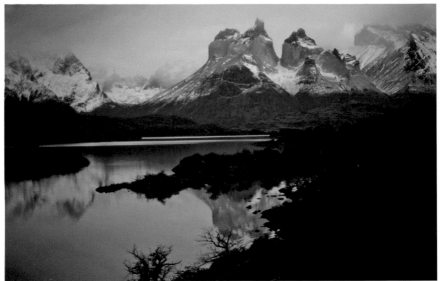

Taking a Trip? Start Here.

My guess is that you have this NYIP *Quick-and-Easy Everyday Photography Guide™* because you're excited about an upcoming trip you've been planning for awhile. Travel is certainly popular, as over 80% of families and individuals will be traveling on holiday for two or more weeks this year. No doubt you want to take really wonderful photographs of your experiences, show your family and friends the most remarkable aspects of your journey, and preserve those memories for everyone to enjoy later on.

Well, for anyone who wants to take better travel pictures, this is the book for you. I've interviewed ten professional photographers—each one outstanding and well traveled— and asked them to share their favorite tips and techniques for taking great travel photographs.

Many non-professionals believe that pro photographers bring home great images from their excursions because they've invested thousands of dollars in their equipment. The widespread belief is that the average shutterbug can't possibly capture wonderful images. I want this book to debunk the myths!

I'd estimate that 85% of all great travel images can be taken with a basic digital SLR (single lens reflex) or high-performance point-and-shoot model camera. The trick is to learn to "see" like a photographer. That's a theme we'll return to again and again in this book.

In fact, at the New York Institute of Photography, the world's oldest and largest school of photography, we have a saying that we keep reciting to students from the very beginning of their studies.

It's not the violin, it's the violinist.

What do we mean by that? People are more important than musical instruments or photography equipment. Camera manufacturers want you to think that the trick to taking great photographs lies in buying the latest camera with more megapixels, more dials, and more features. Pretty soon, they'll have a camera on the market that can monitor your blood pressure, check your email, and maybe even scratch your back! You know what? You don't need all those bells and whistles.

Consider this: I can't play the violin. If I go out and buy a great violin, even shell out $2 million for a Stradivarius (there are only about 650 of them left on the planet from Stradivari's workshop in the late 1600s), I still won't be able to play the violin! I need to learn how to play the violin, not buy an expensive violin and think it will do the job for me. If I don't take the responsibility to learn how to play the violin—and practice playing it—then it doesn't matter if I have an inexpensive instrument or a priceless antique. So it is with photography. I bet right now your camera is better at doing its job than you are at controlling it. Today's digital models are very, very sophisticated instruments. Would you hand the keys of a high-powered Ferrari over to a 16 year old who just got a learner's permit? I don't think so.

That's why we're going to teach you how to take control of your camera. We're also going to help you discover the elements that go into a great photograph. But most of all, we're going to help you develop the Eye of the Photographer—that special skill that will allow you to see possibilities for great photos in the scene in front of you that you would have otherwise missed. And this is particularly handy while traveling. Seeing opportunities to take great photographs will also help you better appreciate the beauty and spontaneity of people and scenery and sights and events around you as you journey through life.

True

There are some photos that require expensive gear—capturing the condor soaring high above the Andes may require a telephoto lens, for example. Michael Doven's amazing "Everest Valley" photograph on page 18 of this book was shot using the latest Nikon equipment from 18,000 feet in the air, as his rented helicopter flew between Kathmandu, Nepal to a Mt. Everest base camp.

Also True

Most great travel photos can be taken with basic digital cameras.

We'll also take up some technical photography matters, but it's important that you understand that those are in many ways secondary to seeing the possibilities in front of your camera. After all, if you can't see the photos, you can't capture them … no matter how much technique and gear you have.

Because it's so important, please permit me one more story to illustrate "It's not the violin, it's the violinist" concept. In my professional career, I concentrated on photographing dancers and musicians, along with photojournalism, travel, and general portraiture. Working with dancers has always been a pleasure, they're very conscious of their craft, and since their art is performance-based, they're very grateful to photographers who can capture the essence of their talent and skill.

I had just landed a new client, a big name in the modern/experimental dance world. Most dance photography is done at dress rehearsals to avoid bothering the audience during a real performance, so when I showed up to photograph this rising star for the first time, she kindly took me aside and told me that she had a new boyfriend who's "an extremely talented photographer." Would I mind if he also took photographs of the rehearsal?

Let's just say that a professional at this type of job likes working with another photographer about as much as a tomcat likes sharing the fence with a feline competitor, but I had little choice under the circumstances and agreed with her request. After all, we had just started working together, and she was the diva.

As the lighting designer ran a final check before the dress rehearsal began, up stepped the mighty ETP (Extremely Talented Photographer). He walked to the middle of the stage, cameras on each shoulder and around

Who Was First?

Historians of photography may quibble over the date. 1839 marks the year that the Frenchman Louis-Jacques-Mandé Daguerre announced the invention of the Daguerreotype, a method of fixing images using mercury applied to a copper plate. Others may credit the Englishman Henry Fox Talbot, who created the Calotype (or Talbotype), using light-sensitive salts embedded in paper to create the first negative/positive photographic option. Regardless of who gets the credit of being first, fixing images transmitted through a lens was an idea that was ready to make itself known in the world around 1840. One thing the scholars don't dispute is that the term "photography" from the Greek *photos* (light) and *graphos* (writing), hence "writing with light," was coined by Sir John Frederick William Herschel, at least in the European world. As if to confirm that photography was ready to burst on the scene, years later it was learned that Hercules Florence, a French émigré to Brazil, had developed a photographic system using silver nitrate and used the term "photography" to describe the process. Alas, Florence's work didn't become known to the world until many years later, so he's a footnote within this footnote.

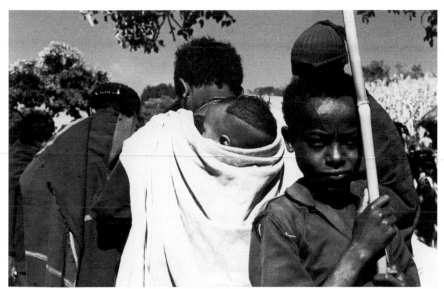

his neck, bristling with gear. Out of a pocket in his very tailored photo vest he whipped out a very expensive incident light meter, and with a flourish, proceeded to hold it out and measure the light—using it exactly backwards from the way it was designed to work! This was like watching someone pull out an expensive trumpet with a flourish, and attempt to play it by blowing into the bell rather than the mouthpiece.

Well, I thought, my only problem with this ETP was going to be keeping him out of the background of my photographs. Let the "dress" begin!

So equipment is always secondary to the person taking the pictures, and I hope I've put your mind at rest regarding equipment. It's a means to an end, but there are many more important factors leading to great photographs—and the professional travel photographers I had the honor to interview for this book were brimming with great tips, suggestions, and helpful advice. They would tell you to spend your money on airplane tickets, hotels, and the other necessities of travel. When and if you decide to get more serious about photography, you may wish to purchase some added equipment and upgrade one camera for a flashier model. But right now, I want you to learn how to get the best results from the camera you already own.

Before we dig into the techniques you'll need to know and hear from our travel photography experts, let's take a few moments to look at what travel photographs really are, the role they play today, and the glorious history of this very special type of photography.

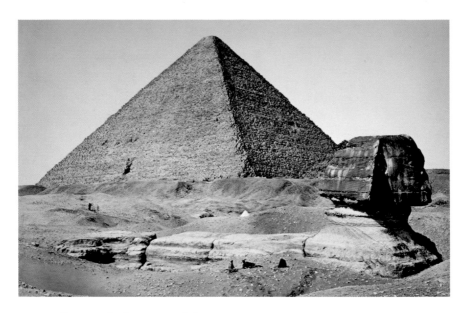

Wonders of the World

Not long after photography was invented back in 1839, using the camera to bring the faraway "wonders of the world" to viewers back home was a very important early application.

Frances Frith, an early British photographer, made several trips to Egypt, Palestine, and Syria in the 1850s. Lugging a giant 16" x 20" view camera that used glass negatives, Frith brought back photos that astounded the civilized world. Remember that before photography, the public relied on painters and their interpretations of foreign lands; the realism of photography blew everyone away.

Another early travel photographer of note was Felice Beato, who took his camera to India, China, and Japan. His images helped drive the late 19th century Western world's fascination with China and Japan.

All these early photographs showed an enthralled populace a number of distant places they'd never see for themselves. Travel was still an option only for wealthy adventurers, and didn't extend to the average family.

At first these images were limited in circulation by the lack of mass media. Prints were made, sold, and passed from hand to hand or circulated in albums. In the closing years of the 1800s, reproduction techniques using photolithography and photogravure made it possible to reproduce photographs in newspapers and books, and the wonders of the world became accessible to the general public.

Opposite Page:
The Great Pyramid and Great
Sphinx at Giza by Francis Frith

The Hypaethral Temple, Philae,
by Francis Frith 1857; from
the collection of the National
Galleries of Scotland

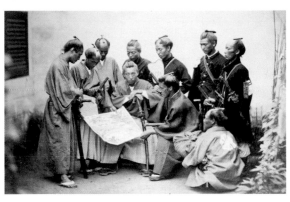

Samurai of the Choshu clan
by Felice Beato. Hand-colored
albumen print, circa 1868.

New Art Form

Before color photography was invented, scenes such as Beato's Samurai photograph (above) were enhanced by applying color via brushwork to the photographic print. Photography, being a relatively new art form, allows even the casual collector to purchase examples of its earliest forms for relatively low cost. Want an early sample of sculpture, perhaps a Cycladic figurine from 3000 B.C.? It will run you in excess of $100,000 and it's probably stolen and you might get a chance to meet some fine folks from Interpol. However, 1/6 plate Daguerreotypes that were made over 150 years ago are available with seals intact in their original Gutta Percha cases for a few hundred dollars, and bidding on eBay routinely starts under $50 for a wide variety of interesting portraits. When I'm travelling, I make it a habit to try to find antique stores and flea markets that sell old local photographs to add to my collection.

Today's Travel Photography

In the early days of photography, the pioneers mostly captured scenes without many people. Exposures took a long time and people tended to move around and blur. Even Beato's Samurai photograph probably required the subjects to hold absolutely still for thirty seconds or more. Naturally, that's easy for a disciplined Samurai, but it's a hard task for most others. Early portraits used chairs with head clamps to help people hold still so their faces wouldn't be blurred.

What a long way we've come in less than two hundred years! There's no limit to what you can photograph. A digital camera loaded with a high-capacity memory card can hold hundreds, even thousands of photographs.

Today there are beautiful full-color books, breathtaking postcards, and millions of Internet pages showing off almost every nook and cranny of the globe—from the highest mountaintops to the ocean's depths. If I mention the Taj Mahal, you have an immediate mental image of it. So too, the Great Wall of China, the Golden Gate Bridge, the Alamo, or Buckingham Palace. If I name any foreign landmark, you can probably conjure up an image of it or find one on Google in seconds. We've seen it all through the wonders of travel photography.

But if we've seen it all, then what's left for us to photograph? In a word, everything. That's because the power of photography still allows us to see things in ways that have never been seen before. Whether it's something on the other side of town or the other side of the globe, there are infinite possibilities to show things in startlingly new ways.

And that's due entirely to you. Your unique way of seeing the world can be documented in your travel photos. Are you interested in architectural details? Does a field of colorful flowers fascinate you? Do you like to sit on a park bench and watch people strolling by? How you view the world is what makes your photographs important and unique.

Go Online

This book is filled with inspiring photographs and helpful tips. To fit them all in, we didn't run descriptive captions about where these beautiful photographs were taken. To find out more about any image, just visit *www.nyip.com/Everyday-Photography.*

Several of the photographers that we profile mention photo releases. For the most part, this is a topic that need not concern you. But if you'd like to learn a bit more, just in case you come upon an extraordinary photograph that includes people and it might have commercial value, just visit *www.nyip.com/Everyday-Photography* for our "All about Photo Releases" article and a sample photo release you can use.

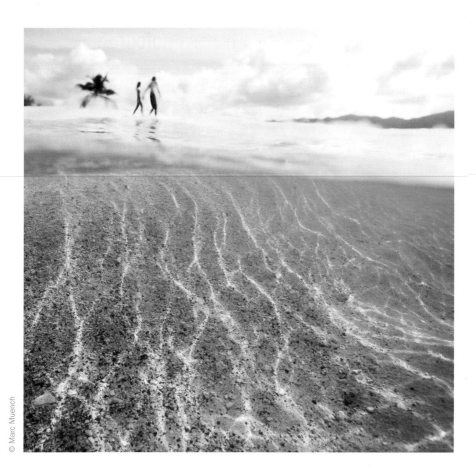

© Marc Muench

It's my pleasure to introduce you to a number of amazing, highly regarded travel photographers who want to share their tips, techniques, and stories with you. Why are they so forthcoming with advice? It's because a dedicated photographer respects the innate ability of each person to see the world through fresh eyes, and they want you to fully express your vision and share what you experience on your travels with others.

Your travel photographs might one day inspire others to travel in your footsteps, help people understand different lands and cultures—or simply amaze your family and friends.

We can't wait to see the wonderful photographs you take on your next excursion, whether your travels are a walk around the block, an afternoon or weekend getaway, a business trip, or a full-blown vacation. I hope this book and its advice will help you take better photographs, wherever you go. Visit us at *www.nyip.com/Everyday-Photography* to share your travel photos—and everything you've learned from the professionals in this book—with me and the rest of the world.

Chuck DeLaney

Director, NYIP

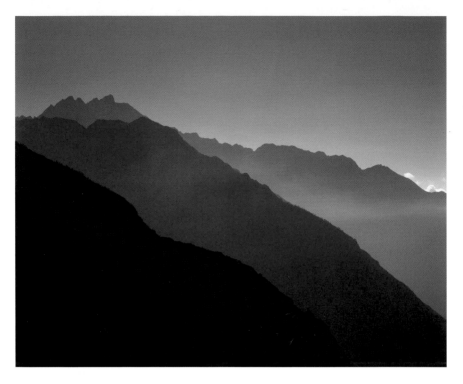

Make a Picture

The transcendentally majestic azure peaks in the above photo were taken by Los Angeles photographer Michael Doven, hailed in a *Nikon Owner* magazine cover story as "Photography's Next Rock Star." He told me about the events that led up to his now-famous "Everest Valley" shot.

My best advice to you is to don't ever "take" a picture. I want you to MAKE a picture.

Some years ago, I rented a helicopter and went from Kathmandu, Nepal to Mt. Everest Base camp. I had tea with the lamas at the highest monastery there and saw Everest—the mountain of my dreams—and took images. As we turned back down valley to return to Kathmandu, I saw the most spectacular- blue-huge mountain ridges in the distance that we would be passing, and I got my shot. The combination of our altitude (18,000 feet) and the clear day caused the color temperature to go very blue to the eye and on the film negative. The result was a view of the Everest Valley we never see.

Traveling Man

The travel bug bit Michael Doven early on. By the age of 25, he'd already logged in trips to over 50 countries. But his interest in photography started even earlier.

In my teens, I had the privilege of assisting John Kelly of Aspen, CO, a great sports photographer. It was during adventure shoots with John that I fell in love with getting up early and going to remote places to create images and art.

In 1991, Michael embarked on an enchanted twenty-year journey in Hollywood where he was able to watch, study, and learn from the greatest directors of photography in the world, all while serving as Production Associate and Associate Producer on major motion pictures like *Mission Impossible: II* and *Minority Report*. His film experience afforded expanded opportunities to take pictures.

As a film producer, I would travel to different countries for sometimes years to get a film made. I would shoot stills on my weekends and whenever I had a day off. I'd most like to visit Nepal again and go trekking there; beautiful country, beautiful people. I've never been to Alaska and Africa, but they look very photogenic and I'd like to travel there!

In 1996, he signed up for and completed NYIP's *Complete Course in Professional Photography,* all to improve his basic photography skills and shifting his focus from motion pictures to still film. Now his fine art photography is represented worldwide by Christie's International Auctions, and his work has been shown at the Venice Biennale and various New York and Los Angeles galleries. His photography has also been featured in *People, HELLO!, OK!, MATCH!,* and hundreds of others publications and websites.

Shoot Like a Pro

It's a golden opportunity to have Michael, and nine other world's-finest photographers offering their advice to you, and to anyone who wants to take better photos while on holiday or a short trip. The core of Michael's advice is how to approach each photograph you take.

If you want images that you're proud of, then go out to CREATE these images. They don't just happen by chance or because you happen to have a camera in your pocket. True artistic images are not "shot"—they're "created! My best advice to you is to don't ever "take" a picture." Instead, I want you to MAKE a picture!

Making and creating a memorable travel photo is what separates the professional from the amateur. The amateur just fools around with the camera and photography because it's fun—and that's true and fine—but the pro takes the extra time, care, interest, and actions to cause a photograph to be the best image he or she can make.

Always strive to improve each photograph you take. And be willing to shoot more shots, and check the light and the angles and continue to study the shots you've made to try to get the best results. Of the 100 or so photographs on my website, only about three resulted from me recognizing great light and running out right then to shoot in that light. And even for those shots, I had staged a camera nearby and was hoping for great light and was ready for it. But 97% of the photos I'm proud of were premeditated and planned for shoot sessions. I created those images on the shoot.

Michael is not a fan of "accidental" photography. He gave an example: one Sunday morning near where he lives, he decided he'd purposefully "create" images near the ocean. He planned the exact gear he wanted to bring to the beachfront, picked the exact spot with the right scenery, and thought in advance about what specific images he was looking for. He went to that spot for the sole purpose of capturing beautiful images.

If you plan a photo session in advance, no matter where you travel, you'll shoot images you'll be proud of nearly every time. I recommend this to anyone who wants to improve their shooting. Simply put, this is the methodology of a professional photographer: decide to shoot, plan your shoot, prepare for your shoot, and go do it. Once you're on location, do your best to constantly improve your results and take multiple shots. When people go "WOW!" when you show them your images, you know you're improving.

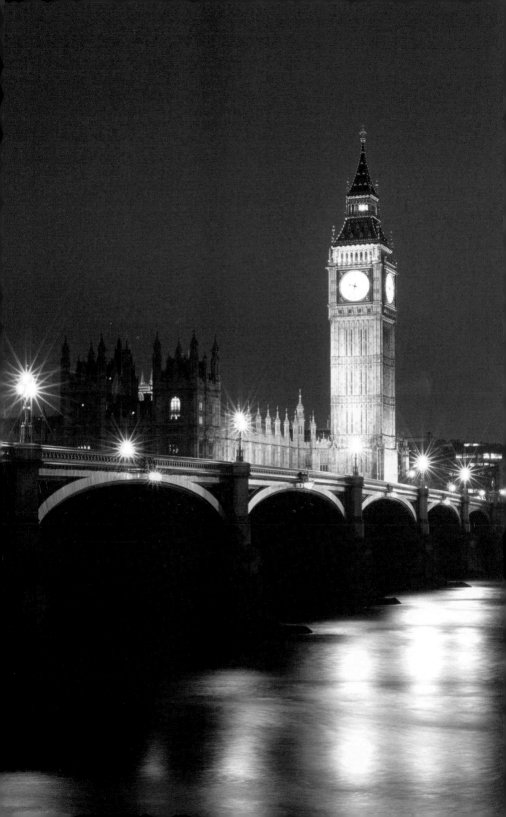

Michael's Jungle Rules

Michael teaches his photography students and crew using the following just-do-it rules of thumb, but he added, "Please, please break each rule if you have to. Photography should be fun, and I don't want this to seem like homework or an army boot camp!"

1. Don't TAKE pictures. Give pictures, create them, and grant beingness and life to them. Liberally, give photographs to your subjects and to others to help their lives. Help people and their businesses with your images.

2. Learn how to hold a camera! Hold it strong and stable like a professional. Your legs are a sturdy tripod, your torso moves, and you compose for the end of the shot if your subject is in motion. Life is a contact sport, so be active when you're traveling and making photographs. I want you to move, communicate, and be active and alive!

3. Use available stabilizers to keep your camera steady while shooting: walls, cars, trees, objects—lean or brace the camera against them if you don't have a tripod.

4. Look at the light and shadows composing each shot. Use available light and see it and be willing to physically move people to better-lit areas. They'll appreciate that you care enough to move them to a better spot for a better shot.

5. Use natural reflectors (white sunlit buildings and surfaces, for instance), bring reflectors (pop-open discs are easier to take with you), and recruit assistants to help you with lighting for a great shot. Ask people for help; people love to help!

6. Change the viewpoint and angles of your shots. Go up and down. Move around. Be willing to look for special shots in odd places and awkward angles. Sometimes I like to shoot low from the floor or from a rooftop.

7. Here's one of my biggies: PREPARE for a planned shoot! A planned shoot will help you "make" your best travel photos ever.

Checklist to Prep for a Shoot

- ❏ Check Batteries
- ❏ Clean Camera Lens
- ❏ Check Lens Cap
- ❏ Clear Memory Cards
- ❏ Do Camera Settings (in advance, including flash settings)
- ❏ Arrange Camera and Gear in Bags for Quick Draw
- ❏ Set up your camera(s) at home or in your hotel in advance of the shoot. Think what you'll need. Guess at the settings (ISO, color temps, and other settings) and pre-set them for easier shooting. This is important for catching fast action wherever you're going. Pull out your camera and start right away shooting, then make adjustments when you can. Arrive ready to go!
- ❏ Search online for general information for specific travel sights you'd like to shoot, such as the Taj Mahal. You'll learn a lot and start to plan where you'd like to shoot in advance. Also look online for general "photography tips" such as "photographing fireworks" if you know you'll be encountering something special or tricky to shoot.
- ❏ Get out early to the location you'd like to photograph and shoot in advance. Learn the light that day and anticipate the light. If you're shooting a special event in a foreign locale, like a sports event or a wedding, anticipate key critical moments—and be ready to shoot!
- ❏ Plan your indoor to outdoor transitions! How? If your camera allows it, set your exposure for indoor conditions until you're happy with the results you're shooting, and then do the same for outdoor conditions. Write down or remember both settings so you can transition rapidly from outdoors to indoors or vice versa—or carry two cameras and set one for each.
- ❏ You're shooting with a digital camera, so you can make many mistakes—but try not to miss a shot. When any shot requires fast action, get the shot as you correct. Pull the trigger, keep snapping shots off, and you can always delete and edit out bad shots later on. Your mantra should be: shoot and adjust, shoot and adjust.
- ❏ Don't pause too long to study all your shots on location. You might miss the important moments in life! Just allow yourself to make quick checks on exposure, focus, and overall feel. I never want to catch you being a monkey or an ape: "Oooh-oooh-oooh, isn't that shot cool!" Get back to creating images. Edit later!

Visit Michael's website at
www.michaeldoven.com.

- ❏ Sneak candid shots while you're on your travels. Here's how: shoot something nearby what you'd really like to take a picture of and at about the same distance ... then swing around and calmly shoot your subjects so they don't quite really see your lens on them for any amount of time.
- ❏ Cleaning camera lenses with a T-shirt is fine! Good clean cotton is fine, and you don't need all the fancy cleaners.
- ❏ Don't purchase and use clear protection filters for your camera. I never use them. I want that expensive glass of the actual lens for my image, not a cheap $30 filter.
- ❏ Study the work of photographers you admire in magazines. Check the eyes of the people in their shots to see exactly where the lights were placed! The eyes are a mirror for the light placement, and you can learn how to begin lighting your own subjects that way, too.
- ❏ When using a strobe for indoor or night photography with people posing for your shots, follow this recipe.
 - · Strobe: f5.6 at a 60th of a second.
 - · Get the strobe off the camera if you can (further from the lens).
 - · Use fill flash during daylight and bright sun shots to open the shadows.
- ❏ If you're working on a shot and you like the elements at hand and you feel it's working and has the potential for a great shot, then stay longer and work with it. Try shooting a few more angles, for instance. But go the distance: after it's all working for you and you have your dream shot, now go for something over the top like yelling out to a crowd "Okay, everyone cheer on the count of three!" And keep shooting when they and your other subjects think they're done. Change settings and shoot more. Keep shooting, shooting, shooting.
- ❏ Get signage and logos in your shots for storytelling. That is, make sure to include signs or icons or objects that add to your message and add to understanding the image and where you were in your travels. A shot of a confident athlete in front of the Olympic rings logo will look different and tell a better story than an image of the same athlete standing against a white gym wall.
- ❏ Sunrise and sunsets are golden! Plan your shoots around them.
- ❏ And finally, your images communicate. They're a way for you to communicate to others and they reflect your choices as an artist. Yes, you're going to be an artist when you travel with your camera. If you like what you've photographed and the way you've made your compositions work, then you've made art for yourself. If others like it as well and it actually communicates to them too, now you have art that others will desire. And it's all good.

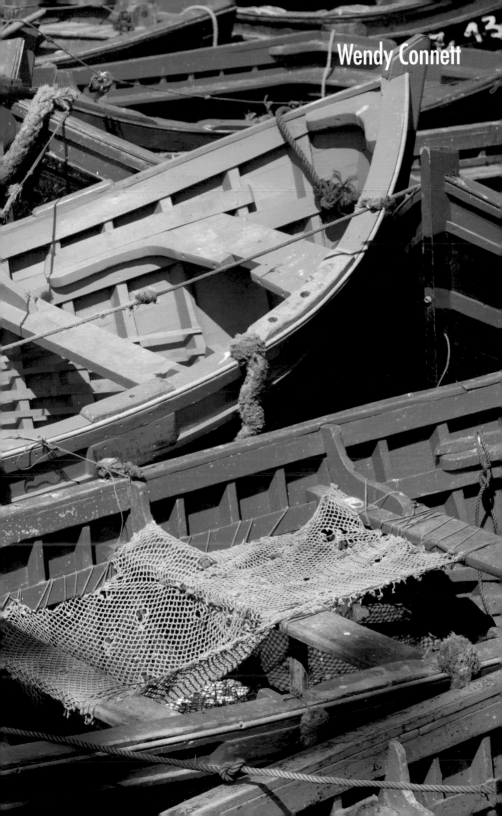
Wendy Connett

Start at Home

Before leaving for that once-in-a-lifetime trip, develop your travel photography skills at home.

With a father who was a talented amateur photographer and an education at the (now-defunct) World of Tomorrow School that offered a photography class and had a darkroom, it was natural for Wendy Connett to go into photography. She first explored print journalism, and then photography was a natural extension of that. Now she's a successful travel photographer—she was first signed by an agency in 2003, and her work has appeared in *National Geographic Traveler, Time, Travel & Leisure, Forbes Traveler, Fodors,* and other magazines and publications.

And yet for all her globetrotting, Wendy emphasizes that travel photography should start at home. You don't have to have an itinerary spanning months and continents in order to start getting into taking good photographs. In fact, her longest assignment was a month-long job shooting a guidebook for New York City, where she's based. The job involved shooting 60 locations in 30 days. "It took me to all five boroughs, and places I'd never seen in my home city," she said.

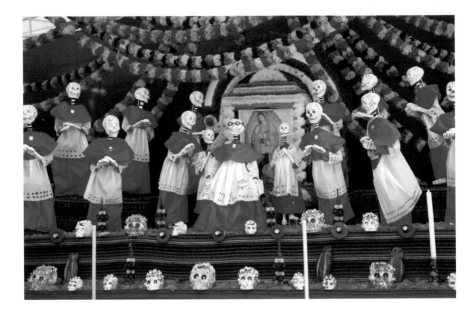

Think "Local"

Wendy's advice to any would-be travel photographers is to start in your own backyard. After all, if you didn't live there, it too would count as "travel" photography. Before leaving for that once-in-a-lifetime trip, develop your travel photography skills at home by giving yourself what Wendy calls "self-assignments."

No matter where you live, there's always travel-related subject matter. It could be a scenic view, a local monument, or a community festival. You'll also have the advantage of snapping photos at different times of the day and year, and you'll have local knowledge on the best or unique views.

The best way to start taking better travel photographs is by making mistakes and learning from them, something you can do at home ... without regrets.

Despite her hometown satisfaction, Wendy is eager to keep traveling, cameras and equipment in hand. "I shoot a lot of travel stock photography for agencies, and there's no greater joy than getting off a plane and shooting a city for the first time, with a fresh eye."

She told me that the list of places she hasn't visited and would like to is "endless," but at the top of her go-to list is Rio de Janeiro. "Brazil has tremendous energy, a vibrant culture, and a metropolis surrounded by stunning natural beauty—it's all extremely appealing."

It's difficult for her to name any one favorite destination, but she's particularly enjoyed photographing the rapidly-growing cities in Asia, such as Shanghai, Hong Kong, and Tokyo. But the counterbalance to this is that she equally enjoys the colonial cities of Mexico.

Build Rapport

Wendy's range of interests helps make her a top travel photographer. She said that her hope is to create images that will inspire her viewers to make their own trips abroad.

My goal is to capture a well-rounded view of a destination and take photographs that transport you there and make you want to go. This includes landmarks, street scenes, food, markets, festivals, people, and everyday life. I also specialize in night photography of cities, particularly in Asia.

I was impressed with her knowledge that the life force of any culture resides in the people who live there. It follows that she's worked diligently to find good ways of photographing total strangers. And what are her tips for photographing the people she encounters on her journeys?

For close-up portraits, building a rapport is key. I engage with people first and gauge whether they might be open to having their photograph taken.

I always learn a few words in the local language, at the very least hello, please, and thank you, and then I smile, make eye contact, and ask their permission. Courtesy and the effort made to learn a few words in the language of the country you're visiting will go a long way.

I don't ask permission for candid street scene shots where there's often more than one person. But in either portrait or street scene scenario, I always keep cultural sensitivities in mind—religious communities are one example.

Even with a few words of the native language, Wendy finds that it's still difficult to obtain releases, but bringing a few releases in the native language can help with this. "Most of my travels are overseas, so language barriers can make it difficult to obtain releases. Most of us wouldn't want to sign a document presented by a stranger. However, I always keep releases on hand in the local language, and when the opportunity arises, I ask."

Consider Your Composition

Here's the secret to photographs with the most visual impact: keep your composition simple. In photography, less is often more. The natural tendency is to look at the middle of your viewfinder, where most people focus on a subject. But also look at the edges of the frame to make sure there aren't any distracting elements. Move in closer to the subject to crop out distracting elements and fill the frame.

Wendy's Top Tips

1. Take Wendy's "easy approach" to photographing strangers. After a rapport is established (see page 27), smile at your intended subject and ask if it's okay to take their photograph. People often tense up when a lens is pointed at them. Smile, chat, and use humor to put them at ease. A smiling or relaxed, natural-looking person is much more photogenic than someone who looks self-conscious, the end result of which is "a mug shot fit for a passport photo or a driver's license." With a digital camera, it's easy to show people the results on the spot and offer to email/send them a copy if they want. In destinations where not everyone can afford a camera, this is especially appreciated.

2. "Avoid the crowds," said Wendy. Travel photography is often a waiting game. It's a common occurrence to show up to photograph a monument you've waited to see all your life only to find a huge group of unruly tourists. It will be a mob scene! Fortunately, large tour groups rarely stick around long, so just wait them out and start to scout your shots while you wait for the crowds to thin. More on-location advice:

 - Generally you can avoid large crowds if you plan to visit a popular location late in the afternoon when most of the tour groups have gone home.

 - If it's just one person distracting you from taking your dream shot, take a few steps forward and/or zoom in to crop them out of the image. If this isn't possible and you've waited a long time for them to leave, politely ask them to move for a minute or two so you can take a photograph. Most people comply.

3. Find ways to weather the weather. Torrential rain while traveling can destroy your soul and equipment. But not all travel photography is an outdoor "sunny blue skies" affair. There's still plenty to photograph, even in bad weather. Wendy's favorites include:

 - Indoor markets selling food or crafts.

 - Interesting cuisine.

 - Beautiful textiles.

 - Local crafts and the way they're displayed—as well as the vendors selling them.

 - All of these often present opportunities for beautiful travel photography and they'll give those who view your photographs a true insight into a culture.

4. Travel with caution and street smarts. When photographing an unfamiliar destination, don't walk around carrying an official-looking camera bag. It can make you a target. Instead, take only what you need for the day (a spare battery, memory cards), put your camera in a smaller padded case, and carry it in an everyday-type bag. Other ways to keep your equipment safe and sound:

 - When taking public transport, put your camera away before boarding a train or bus. It's also a good idea to put your camera away before hailing a cab.

 - Keep an eye on your camera as you would your wallet to deter pickpockets.

 - Never leave equipment in a hotel room without locking it up securely and keeping all your valuables out of sight.

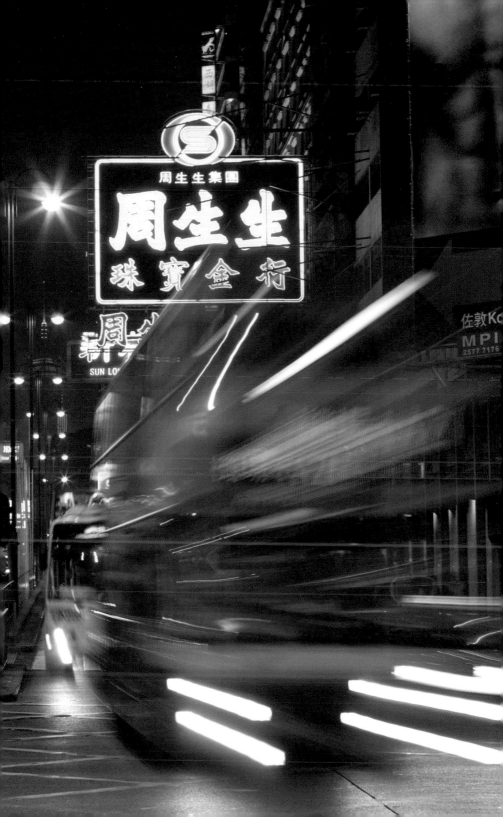

5. Remember that "More is More." There's nothing worse than taking a once-in-a-lifetime shot, only to realize your memory card is full! Take ample memory cards when traveling. It's better to have too many, and you're also covered in case one fails—which is bound to happen at one time or another. Also bring a spare set of batteries; you don't want to run out of juice at an inopportune moment.

- If you're on a particularly long trip, consider bringing a portable storage device, like an external hard drive attachment for a laptop or tablet computer. There are many on the market of varying capacities and price points.

- When you get home, download your photographs to more than one device. Back up your photographs to an external hard drive, in addition to the one on your computer. All hard drives eventually fail. You may also want to burn your favorite images to DVDs.

Visit Wendy's website at *www.wendyconnett .com* and her blog at *escapenewyork .blogspot.com.*

6. Follow Wendy's rules for taking photographs with great composition.

- Photographing objects in odd numbers (three trees in a field instead of four, for example) is more visually appealing.

- When shooting landscapes, pay attention to the horizon and make sure it's straight, not tilted.

- When photographing people, try to keep your backgrounds uncluttered.

- Move in close for portraits.

- "I don't necessarily pose people, but I will ask them to shift a little if there's a very distracting background or I can better position them in light."

- In thinking about composition, consider the eye level you're using. The natural tendency is to shoot photographs horizontally at eye level. But don't forget to shoot the vertical in addition to the horizontal. To do this, try crouching down or standing on something such as steps to get a different view

- If the situation permits, lie on the ground to get what's called a worm's-eye view. This works particularly well when you're photographing tall structures.

- Another classic way to achieve a different view and a very pleasing composition is to visually frame the subject of your photos through a window, doorway, or arch.

- Seek out unique views on your travels! Do you have a view of a cityscape or major monument from your hotel room or the roof of your hotel? Take advantage of views that not everyone else will have access to.

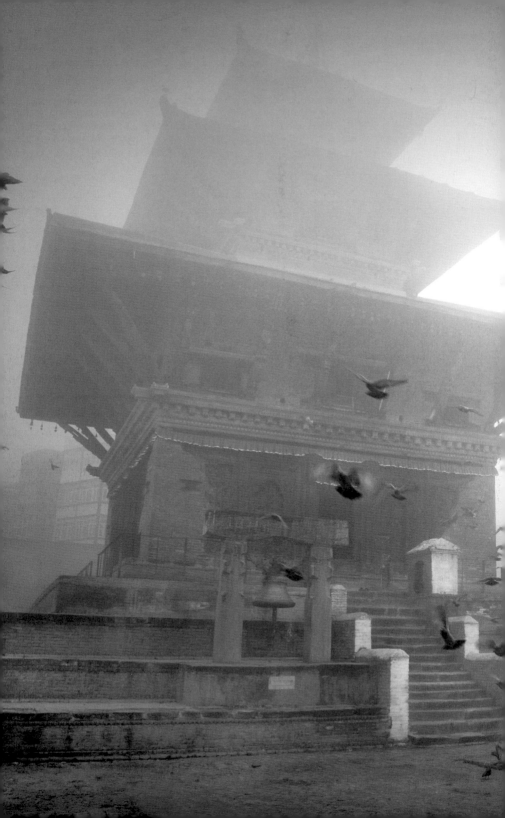

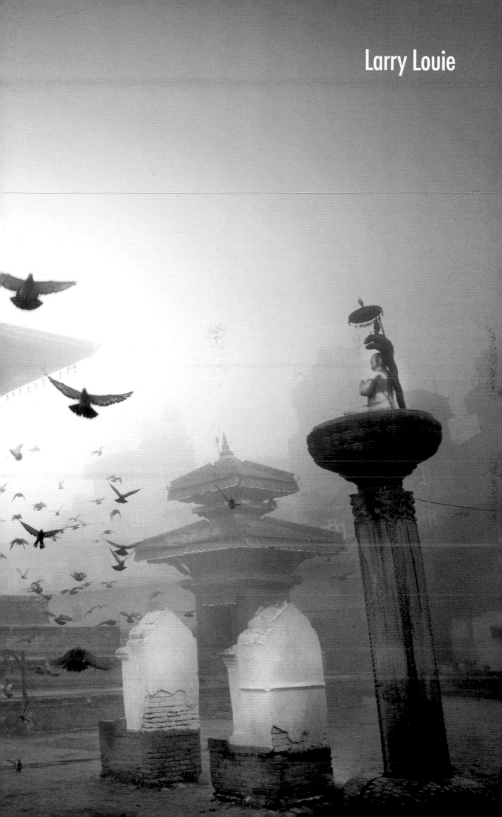

Larry Louie

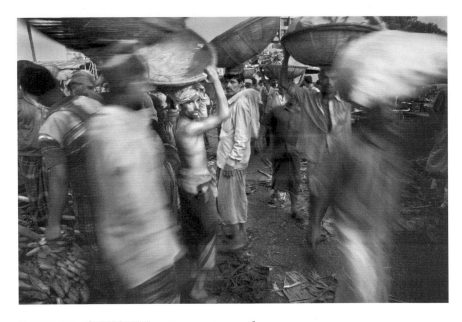

Be a People Person

To me, travel photography is more than just a pretty face at a pretty place.

Larry Louie may not have risked his entire education in order to get a shot, but he was late for one of his first exams as a student at the University of Waterloo because he woke up to a foggy day and just had to run out and photograph it. Since then, he's devoted his life to his twin passions: optometry and photography. Louie runs a successful eye care center in Edmonton, Canada, and travels the world, having exhibited his work from Spain and Italy to London, Canada, and California.

His work took a new turn about twenty years ago, when he saw an exhibit of black-and-white images by Joseph Koudelka. "Then I knew that I wanted to do photography like that," he told me. And since then, he's concentrated on creating striking black-and-white documentary imagery that has earned international acclaim.

Photograph Your Passions

Larry's two life passions dovetail with his work for Seva Canada (*www.seva.ca*), an international non-governmental organization whose mission is the elimination of preventable and treatable blindness around the world. Its goal is to provide funding and expertise to partners in developing countries to create sustainable, economically viable, locally managed eye care programs that will continue to serve people long after Seva's involvement is complete.

Larry sees working for the improvement of the world as essential to his way of life.

Besides my own projects, I like working for social causes, documenting social issues, and working with NGO's such as Seva Canada and Oxfam UK. I worked on a global health campaign with Oxfam International in Western Nepal to increase awareness the lack of medical services available to women in Nepal. The actual photography shoot will take about 10 days.

My longest assignments are usually my own. I have gone back to Tibet and Nepal many times. In Tibet,

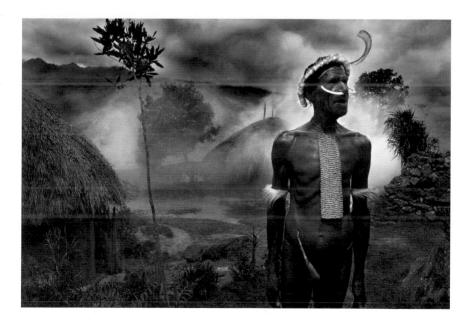

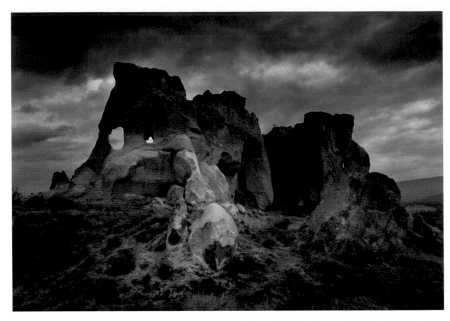

I'm working on the disappearing Tibetan culture— from a more objective point of view (besides the political pressure), and more on how modernization and urbanization are changing people's lives and cultures. In Nepal, I'm working on the issues of the growing slum areas in the cities.

Valuable Assistance

My wife travels with hand puppets, balloons for the kids—and once she even brought a knife sharpener to Papua, New Guinea (she'd heard that they had metal knives and no sharpeners). She keeps everyone distracted, and she's enjoying herself and I can do my own thing and take pictures without being the center of attention.

You might think this approach results in gritty portraits of the more troubling side of life, and that's true: most of Larry's photographs show people in disturbingly difficult situations. But what makes his photographs work so well is that he also sees the brighter side, even in the slums of Kathmandu or in the squalor of the poorest sections of Bangladesh.

I like photographing slums around the world. It's not a popular topic for travel, but I find the people living in slums very interesting. It's also very visually challenging and I like that. I'm not much for shooting iconic images.

I love to travel into a country with an open agenda and just wander and shoot the street life. I love to shoot in third world countries where life is harsh and difficult but at the same time beautiful in my eyes—the laughter of children, the strong sense of community in areas where life is difficult.

Focus on People

For Larry, as for many people, his interest in travel photography began with an interest in seeing "what makes a place 'tick'—and that usually revolves around the culture and the people in that area," he said.

I'm constantly amazed by the ethnic and cultural diversity in our world, from our gender to our skin color to our race and our religion, and the differences in our languages, beliefs, and customs. But unfortunately it's also these differences that has caused so much conflict in our world in the past and now. There must be a way of peaceful coexistence between people of different races, cultures, and value systems.

In this book, we're here to help you take better pictures as you go on your own travels, whether it's a winter getaway to the Caribbean or a first-time exploration of Europe. But I hope you'll get inspiration from all these photographers for whom travel has become more than the occasional escape. For Larry Louie, travel photography has become "a lifelong project."

To me, travel photography is more than just a pretty face at a pretty place. I document cultures that are threatened by modernization and globalization, cultures facing rapid change and even maybe extinction in our lifetime. I document the social issues and explore the challenges that arise where people's lives are caught between the past and present, where modern society has touched but left behind.

But the underlying basis of my photography, as with most travel photography I think, is to foster intercultural understanding and tolerance as a means of promoting friendship and peace around us. I think when people begin to understand and respect their differences, to recognize cultural diversity, and to see differences where they exist and accept these differences without judgment, then they can begin to see the many similarities.

People will eventually realize that, although they may differ in customs, traditions, and value systems, they share the same hopes and dreams for the future. Learning to understand and celebrate diversity is the most important step towards fostering peace and cooperation. Peace will only come when individuals turn their hearts and minds away from hatred, bitterness, and exclusion and move towards mutual respect, tolerance, justice, and sustainability.

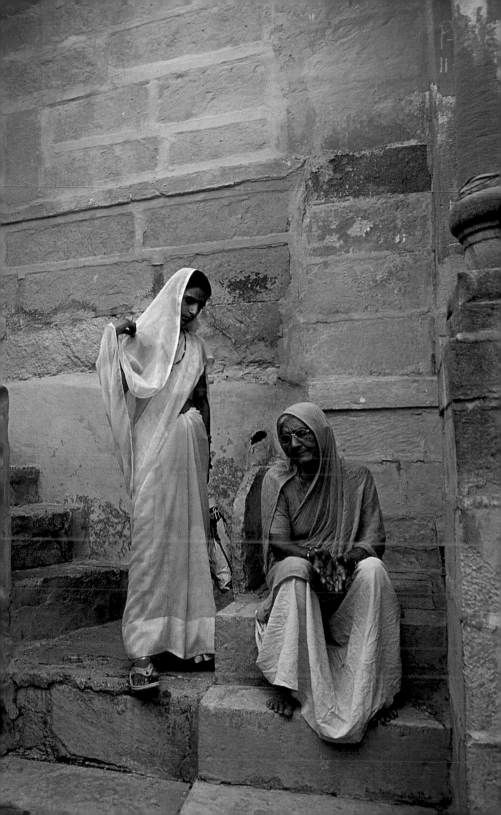

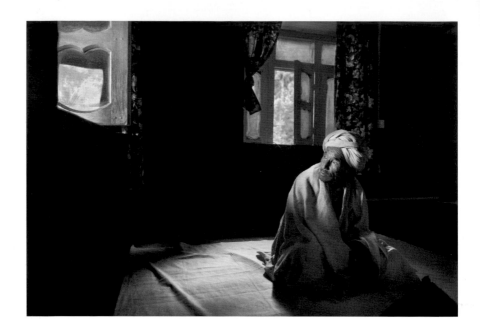

Larry's Photography Advice

1. Expect the unexpected. That is, be very observant. Try to be original. I see too many clichéd images out there.

2. Of course early morning and late evening light is great, but this shouldn't limit when we should photograph. Sometimes harsh lighting can provoke a very interesting photograph. You know, I really like all types of lighting. Look for shade and work with the light.

3. Be careful and be picky about how you compose.

4. The background is just as important as the foreground in the final look of the image.

5. Sometimes you need patience. One might need to wait for the distractions to subside before you take a photograph.

6. One of the most challenging things is to ask children who you don't want in the picture to move out of the picture. Have your guide or travel companion help you do this.

7. Visual balance is essential for a good image. Keep it simple, make sure the background doesn't interfere with the foreground, and break all the rules of composition. Rules will limit your imagination!

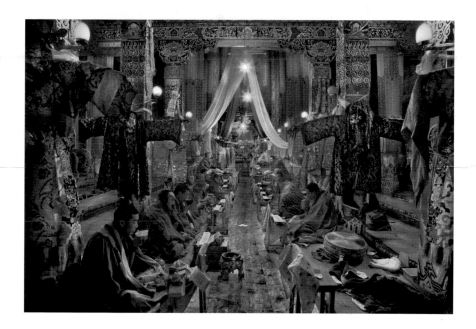

8. Here are my tips on must-have gear when traveling.

 - I normally don't use a tripod. I find it too slow when trying to snap quickly.

 - I'll use reflectors, especially photographing people in interiors. I bring a small white/silver reflector.

 - For camera gear, I keep it to a minimum. I use a Canon 5D Mark II or III, and 2 lenses: a 24mm f1.4 prime lens and a 24-105 f/4 zoom. I also may bring an 85mm f/1.2 prime lens.

9. Respect the laws of the country you're in, and don't shoot "sensitive" facilities where they've posted "No Camera" signs (e.g., customs areas, military installations, etc.).

10. Always be creative. Look at classic subjects at different angles, and have a local person be part of the image to give it a more personal feel.

11. A local guide who speaks the local dialect really helps. For example, I used a female Tibetan guide who speaks the local dialect help me to gain access into a Tibetan Monastery which I would have never gained access to otherwise.

12. Sometimes having connections with an organization such as a NGO or a hospital also helps. Most hospitals won't allow photography, but if you're on an official assignment for an organization, doors will open for you.

Visit Larry's website at *www.larrylouie.com.*

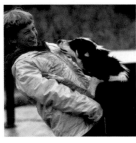

Veer off the beaten path to discover exceptional photographic opportunities.

Be Adventurous

There's a lot of debate about whether creativity gets handed down along with the family silverware and the genes that make us fat or thin, but when I interviewed Peter Guttman and his son, Chase, there seemed no question that there's a direct pipeline from father to son, at least in terms of a love of photography.

Chase Guttman, at 15, is already an award-winning photographer, having landed the 2010 Young Travel Photographer of the Year Award. He's visited over 35 countries, and he's led photography tours and presented seminars for a luxury tour company. He's had a month-long travel assignment for Fodors Travel Publications. His photographs have been exhibited at the Royal Geographical Society in London. He won a Grand Prize in the *National Geographic* 2011 Photography Competition for Kids and his work was featured in *National Geographic Kids Magazine*. He's also a contributor to *Light Stalking, Family Travel,* and *The Huffington Post.*

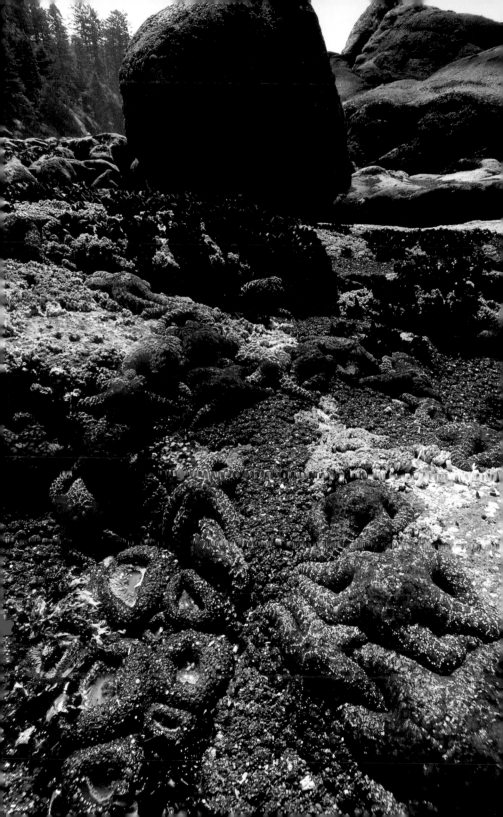

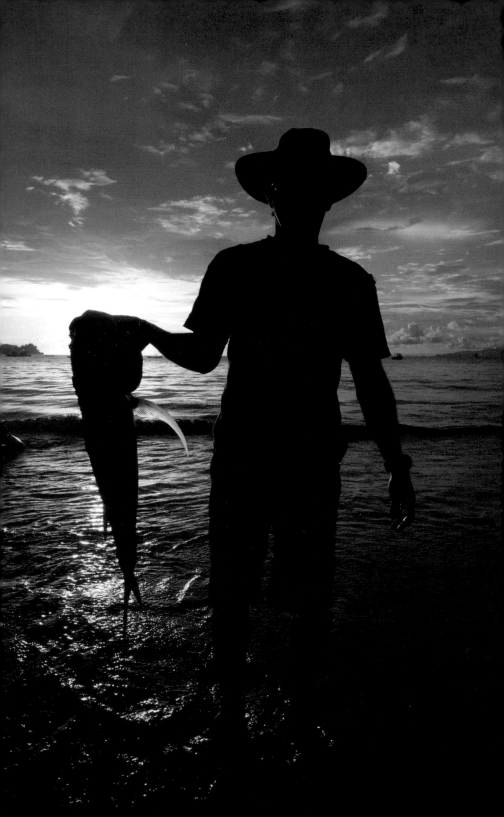

Photography Can Be Bonding

When Chase was a baby, he was watching as his father Peter Guttman projected images on his living room wall in a series of popular travel photography slideshows opened up to the public (see Peter's travel photography starting on page 102). For his part, Chase can see how his early photography education influenced his own work.

I was constantly evaluating the photographs my father had taken, and I really digested the aspects of the medium. While he never pushed me toward it, I saw this amazing lifestyle that came bundled with travel photography—that really inspired me to become part of it. Of course, my parents helped encourage me by giving me a camera at age five. But my photographs slowly improved, and I started getting more interested in photography. From that start, I evolved into a pretty decent photographer.

Chase now accompanies his father on travel photography assignments. His favorite destinations are exotic, "out of this world" countries like Morocco which offer a variety of cultural views. He'd most like to go to New Guinea, Yemen (even though it's dangerous, its sights are very appealing to him), and Antarctica. In New York City, he handles his own local assignments without parental assistance.

I believe you should gather experiences and have cool adventures. My classmates are pretty astounded by where I've been and what I photograph, and I enjoy showing them wild and eccentric things that might be just around the corner from where they live. We don't have to travel to another continent to experience the unusual.

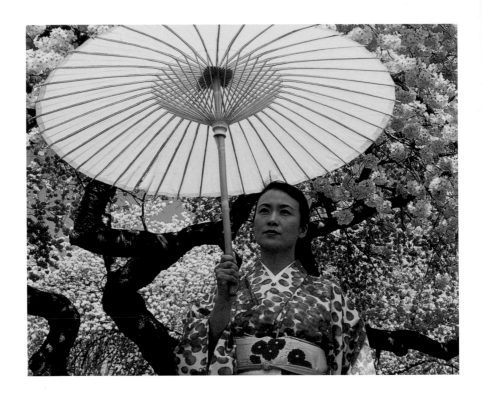

Learn the Art of Photography First

Chase told me that "some of my best images were taken using simple point-and-shoot cameras."

I'm surprised at the number of people who keep buying photography equipment without paying attention to the art of photography. They're missing the point of it, which is to learn the artistic aspect before you splurge on equipment.

Well, there's no doubt that Chase has become an artistic and accomplished travel photographer. He's now able to focus on equipment, moving from a Nikon D50 to a recently-purchased Nikon D7000. He uses a tripod, and while he prefers to take wide-angle shots, he also uses an 80–200 telephoto lens. He has an SB-800 flash, but he doesn't use a reflector; even with a flash on hand, he prefers to use natural light for his compositions.

Chase is squarely in the digital photography camp. He admires the beauty, the colors, and the grain that photographers can achieve when they work solely with film cameras—and he does see a lot of young hipsters who are interested in film. Yet he thinks that as the business of photography shifts, it's important to have an understanding of digital photography. And he's all over social media, with 10,000 total followers on Facebook, Google+, and Twitter.

How to Photograph Strangers

Chase finds that as a teenager, it's easier for him to take photographs of strangers in foreign countries because he's not seen as a threat. And then he's able to see people's reserve begin to lift. Here's how Chase describes it:

Everyone has a veil over their face that hides who they are, and photography helps you get to know someone's story, which is really what makes a captivating image.

When he wants to communicate with someone, and "lift the veil," he'll actively engage with them and have a conversation—or gesture if he doesn't know their language. "It's important to dive right into the action." He likes street photography, and natural and candid imagery. His favorite technique is to hang around watching, blending in, and "taking photographs when I see all the elements—gorgeous lighting, perfect composition, and the decisive moment—coming together."

I went to Pennsylvania Dutch country and went to an Amish Mud Sale. Despite the fact that they had an aversion to being photographed, I was able to get a lot of intimate portraits of the younger kids. At one point I had about 60 Amish kids in their straw hats gathered around my LCD screen as I shared my portraits of them. The more you engage others, the more open they are to your photography.

Chase apologized for using a cliché, but he noted that "we all share a common bond, and everyone is related—and that means it's possible to develop a strong connection with your subjects."

Model Release App

Chase told me about model release apps that conveniently do away with paper releases. Release Me is one such app (http://www.joeyl.com/2011/09/release-me-the-model-release-app). Your subjects just sign a standard or customized form on a tablet computer or SmartPhone screen; you can email a copy of the signed form to your subject, with a copy to yourself.

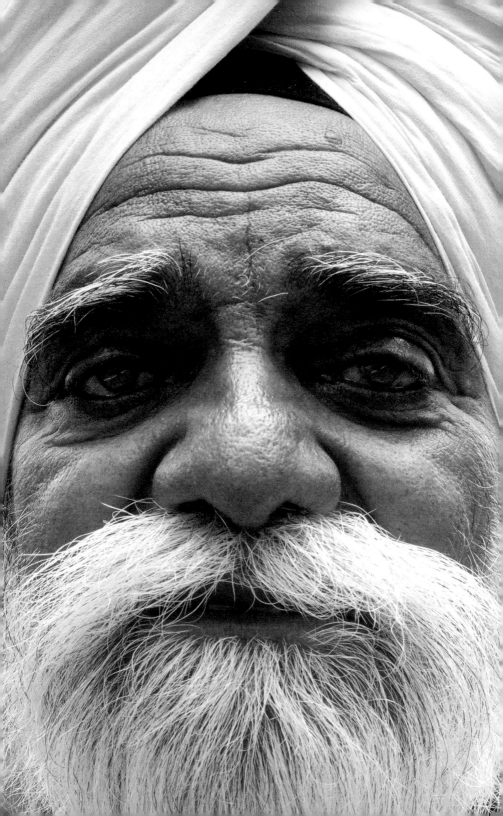

Chase's Top Tips

1. It's essential that you focus more on learning the art of photography, perfecting your craft, and honing your technique, than on the equipment you use.

2. When you create a feeling of intimacy and connection with your subject, you can shoot stunning portraits. Every face tells a unique story, and as a photographer you can expose the realities of their lives, so don't be afraid to get closer.

 Visit Chase's website at *www.chaseguttman.com.*

3. Everywhere you go, diving into the middle of the action will allow you to capture an array of energy and emotions. These images will give your viewer a true sense of your location.

4. Use polarizing filters to get rid of glare and gain more color-popping images.

5. It's important to be in the right place at the right time, and that comes from a mixture of research, observation, and talking to locals.

6. An effective composition simplifies a complicated world by isolating specific portions of your surroundings and bringing visual harmony and order to your environment. So be thoughtful in organizing the elements of your frame.

7. Seek unusual perspectives to help expand the visual repertoire of your frame and dramatically impact your photo's effectiveness. Perspective is what separates an average snapshot from a visual statement.

8. Be adventurous. Veer off the beaten path to discover exceptional photographic opportunities.

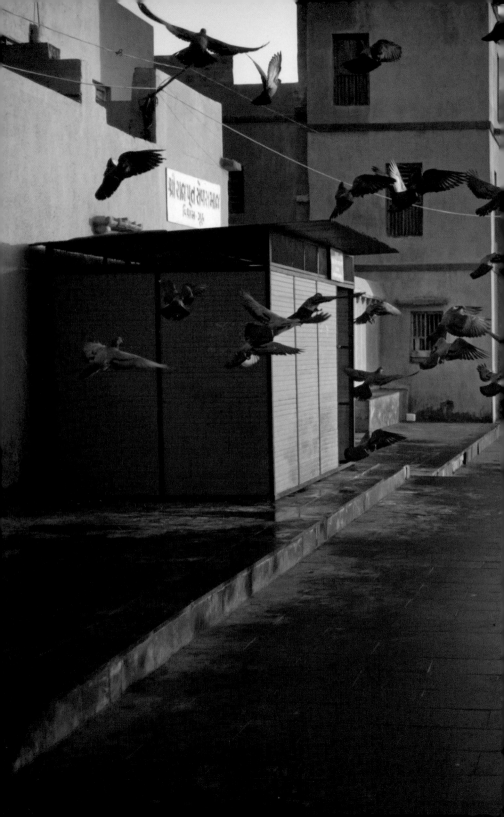

Mitchell Kanashkevich

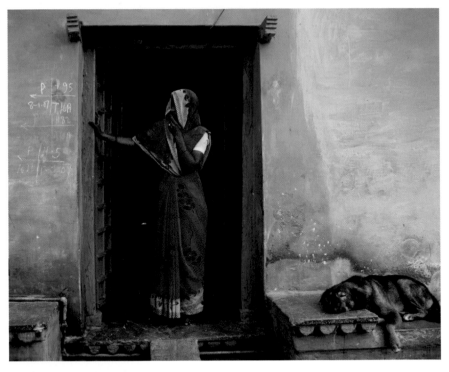

Give a Bit of Yourself

If your image of a travel photographer is a rough-and-tumble fellow bombing around Africa on a motorcycle, Mitchell Kanashkevich will fit your fantasy to a tee.

I spoke to Mitchell via Skype while he was in Ethiopia. He travels the world on his own, making his own assignments and selling his photographs where he can.

Collaborate with Others

What allows Mitchell to lead such a nomadic, creative life in part is his ability to talk to just about anyone from just about any culture in the world. And that, in turn, is thanks to his unique approach—he feels strongly that any photograph of a person is a collaboration between the subject and the photographer.

As long as you have a creative mind and heart, you can take a great photograph with only the most basic equipment.

Visit Mitchell's website at *www.mitchelkphotos .com* and his blog at *www.mitchellkphotos .com/blog.*

This takes more time than many people want to put into their photographs, but it also results in photographs that are compelling and memorable. You need a little more time than to just pass by. If you're traveling in a foreign country that's completely different from yours, it makes a world of difference if you stop and at least try to communicate with the person you want to photograph. If you just stick a camera in somebody's face or photograph somebody while you're walking, that will give you a certain kind of image, one which might not turn out to be very engaging, and might not have any soul to it.

Mitchell, soft-spoken with a lilting Australian accent, doesn't seem like an extrovert, and doesn't see himself as one, either, but he says he's always been interested in people and different cultures. "I was always interested in that side of photography. After I worked up the courage over the years to approach people, that's when I really got into it."

Mitchell's collaborative travel photography approach changes the dynamic between photographer and subject, and he encourages you to try your hand at it, too.

Some people really feel they're taking from their subject when they're 'taking' a photograph. I think that if you do give a little bit of yourself in the process, the person who you're photographing is more than ready to give a bit more of themselves. It becomes a collaborative process once you give a bit of time, once you stop and start talking— something as simple as introducing yourself can make a world of difference.

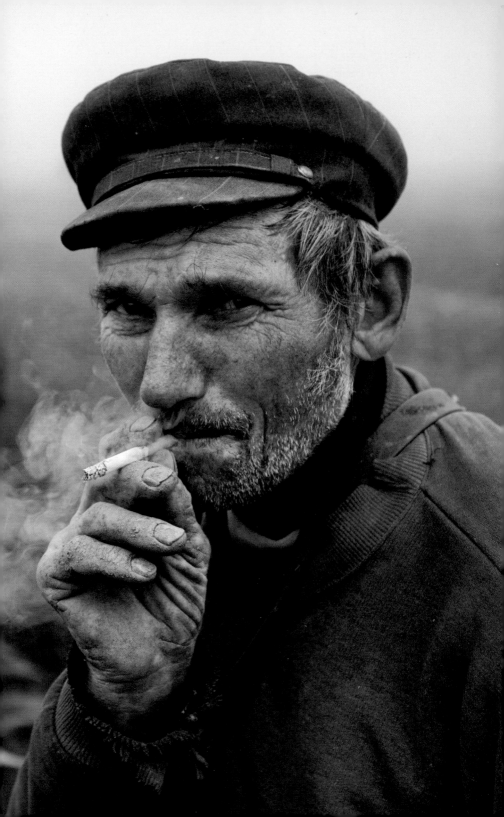

Wait for Someone to Walk In

With other photographs, patience is what really pays off. You may need to wait for a person to walk into the frame before you transform a cold landscape into a vivid, living photograph. This kind of photograph, in which the people in the scene aren't recognizable, can be a boon because you won't need to get a release signed. Consider Mitchell's photograph on pages 52–53, of a holy man walking and birds flying; it wouldn't make sense for him to have approached the man, interrupting him, to ask for permission to take the photograph.

Would he have agreed to this picture? That's a question I can't answer. Knowing people in that part of India, I would say with 99% certainly he'd be okay with it, but it's not that kind of picture—he's just an element in the frame. His face is invisible."

In the photograph below, taken at the foot of Mount Bromo in Indonesia, Mitchell likewise waited for people to walk into the frame.

It's a scene and a person is one element in that scene. Every morning there was a fog due to the temperature change, and I decided one morning to go out and get the photograph.

This image was suggestive of photos from a racetrack, when horses are being walked before morning workouts. They're like race horses, but only in that because they race to get the tourists on these horses later in the day.

Mitchell's patience was put to the test with this photo because he had to wait for about an hour for the sun to be in the right place, so as not to have too much contrast.

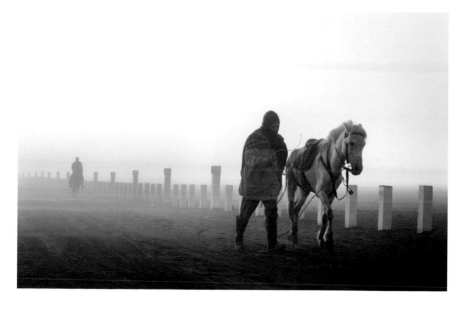

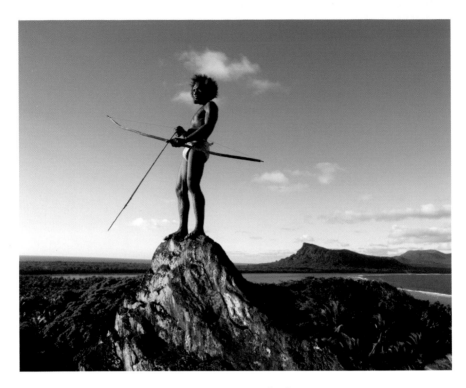

Taste New Ways of Life

While you don't need this level of commitment to get great travel photographs, Mitchell can be an inspiration in terms of really immersing yourself in the culture where you're going to be photographing.

How to Approach Strangers

Tread carefully at first, just take your camera out, look at people and nod, don't push yourself on people right away. See how people react, whether there are smiles or frowns.

Leading up to the photograph on the opposite page of the man in the water, waiting to spear a fish with a homemade spear gun, Mitchell spent a month near his fishing village in the Philippines. He was on an island called Pinai, photographing the people's way of life and their ancient fishing techniques.

For underwater shots, he didn't want to take the risks associated with using compressed air, so he learned how to free dive, and got "good enough to keep up with the fishermen—to an extent!"

Keep Your Equipment Simple

Mitchell's nomadic lifestyle necessitates that he travel pretty light, so he carries one Canon EOS 5D Mark II camera, a 16–35mm lens, and a 70–200mm lens. "Basically those two lenses cover me for everything that I need. It's not the lightest kit, but it's pretty minimal when you compare it to some others," he said.

Mitchell doesn't feel he needs much fancy or expensive equipment.

When people say they need a better camera, I cringe a little bit. Even with SmartPhones, it's amazing what you can do. As long as you have that creative mind and heart, you can take a great photograph with only the most basic equipment. In some of the developing countries, people will get their hands on a simple camera, and they'll do wonders with it because it's all that they have. That's their tool. That's enough.

He knows about this because although to hear him speak you'd assume he was Australian born and bred, he was actually born in Belarus, in the former USSR, during the time of Soviet rule. His parents immigrated to Australia when Mitchell was ten.

Coming from the former USSR, all of us had this attitude. Even as children, when I used to draw, I could only dream of having certain paints, and we just did with what we had. I think the abundance of equipment or technology sometimes detracts from what's important.

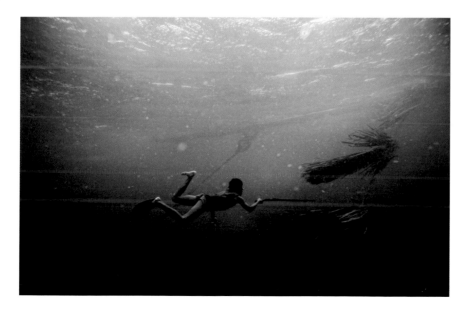

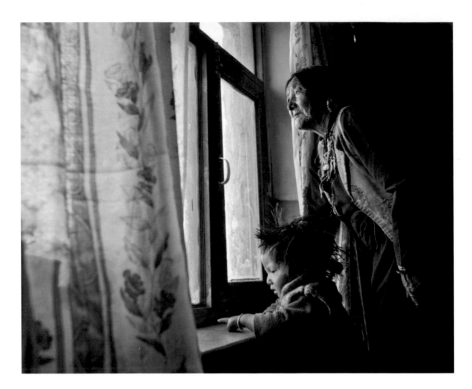

Travel with Loved Ones

Mitchell's upbringing also contributed to his interest in travel; as a child, his family would make frequent trips back to Russia from Australia, stopping at various spots along the way.

There are still plenty of places for Mitchell to explore: for one thing, he has yet to go to South America. In Ethiopia, he's meeting other travelers who are telling him about other parts of Africa he has yet to explore. He's looking forward to taking "the mother of all road trips," swapping his motorcycle for a Jeep, and driving around as much of the globe as he can.

Mitchell said that one factor in his lifestyle is that he can only do it because his wife Tanya wants to travel like this with him, and traveling with her makes his work easier. In many places they go, as a single man, he wouldn't be able to photograph a woman's kitchen, or even a woman on the street, without people worrying about his "ulterior motives."

Tanya's the tortured photographer's wife. She makes it a lot easier. She's also a constant source of inspiration. She has a unique way of looking at the world, and when I listen to her, I cannot help but feel that there's magic in even the simplest things around us.

Mitchell's Favorite Tips

1. If you want to photograph someone, just introduce yourself, and tell him what you're doing. Even if you do it in English, it'll still give you a chance for that photograph.

2. You don't have to spend hours, but you do have to spend some time getting to know people, even if it's just by smiling, approaching them, shaking hands, or sometimes buying something. Even 5 minutes gives a chance for some kind of relationship to develop.

3. I've never had a business card in my life, but what I do have are a few pictures from my home, showing my town, my street, my home. It's easy to have these on your cell phone, and you can show a little about yourself so that people feel a little bit more familiar with you. Then they'll react differently than they will to someone who just snaps a picture and runs off.

4. Go out early in the morning. Tours start later in the morning. A lot of cities wake up at sunrise, and most tourists are still in bed. There's at least an hour when you can go for a walk in the old part of town, and then there's a chance to photograph some of the best local sites and subjects.

5. You can travel with your family on vacation and still get great photos. Find an hour for yourself in the morning, perhaps when your children and spouse are still sleeping—or whenever you can find the time to devote to yourself. Your family may well enjoy getting to know local people through your photography.

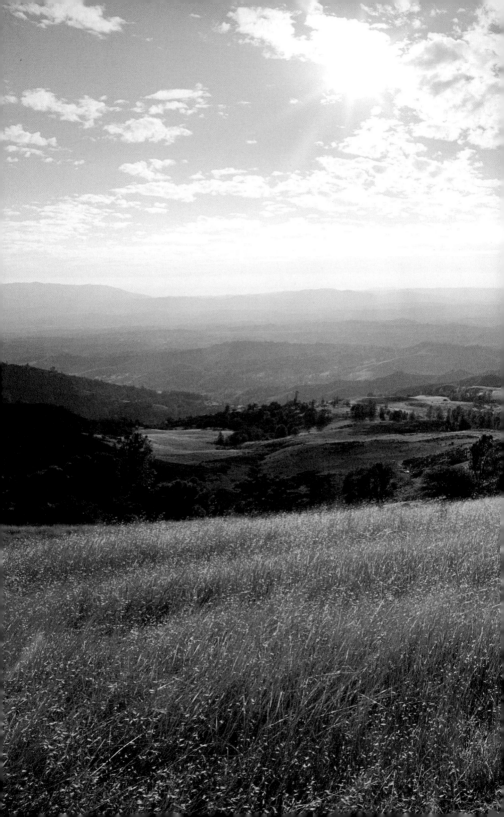

Marc Muench

Capture Outdoor Action

Travel photography isn't only about taking pictures of great churches, tall buildings, and the top tourist sites. Many photographers love to take pictures of beautiful scenery—and when there's a person in the composition, they're usually enjoying themselves in this natural setting.

The best tip I can share with you is "situational awareness." This will give you the ability to predict what is about to occur.

For photographer Marc Muench, travel photography is all about capturing people in action, in amazing natural settings.

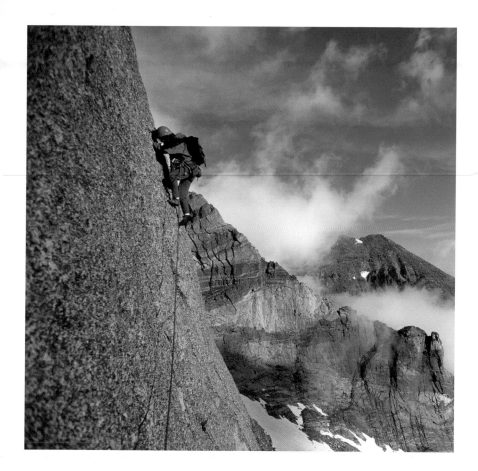

Show Thrills

Skiing, for example, isn't the first thing that comes to mind when I think of Iran, but it took my interview with Marc to show me that yes, in fact, there is skiing in Iran. Marc knows because so far, that's been his favorite trip where he's been on assignment.

Marc has followed skiers around the world, from the expected mountains to places where you'd never think two ski poles would touch down. In fact, it was through skiing that Marc first became interested in photography.

Landscape photography was in our family, so I lived and breathed it. But it wasn't until I became intrigued with skiing and rock climbing that I found my desire to take pictures.

Once I learned how to ski the real steep slopes, I wanted to take pictures that showed the thrill.

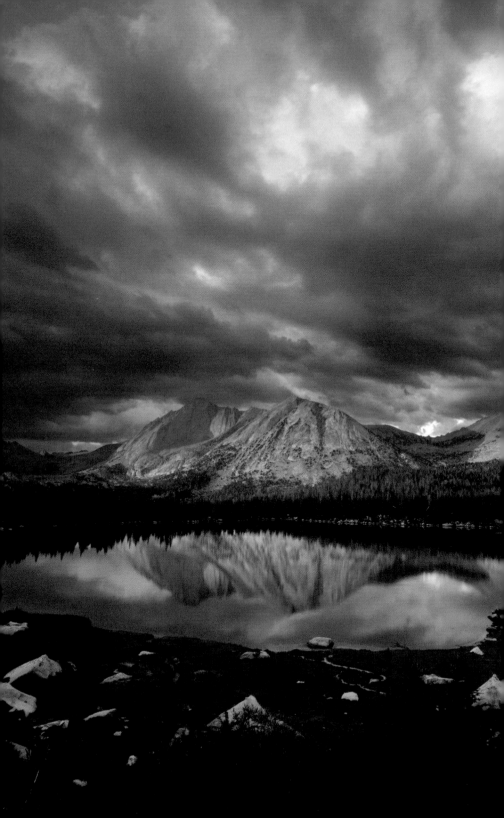

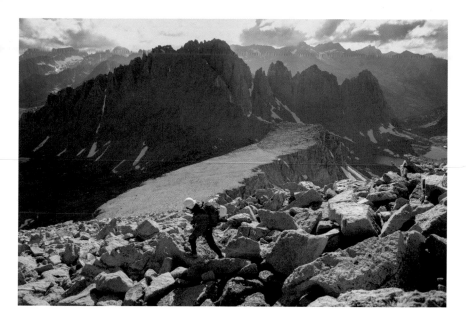

Shoot the Great Outdoors

Today, after putting in a good twenty years into the business, Marc mostly does location work, scenic in nature, with people participating in a sport or leisure activity. He's worked for ad agencies including Hakuhodo, McCann Erickson, Leo Burnett, Grey, IMI, as well as companies such as American Skiing Corporation, Coors, Budweiser, the National Park Service, North Dakota Department of Tourism, Canon, and others.

Not surprisingly, his photography has appeared in magazines such as *National Geographic, Outside, Newsweek, ESPN, Sierra, NPCA, AZ Highways, Ski,* and *Skiing.*

In addition, Marc has several coffee table books, and others for which he teamed up with his father, noted photographer David Muench—and between the two of them, they have 50 photography titles and over 14,000 stock photography images (specializing on outdoor subjects) between them.

Every year my images are published in multiple calendars in 4 different countries. My latest book is titled *Exploring North American Landscapes.*

Each book takes about a year to complete, but Marc's longest commercial assignment involved three trips in thirty days, photographing and filming the Natchez Trace Parkway for the National Park Service.

While Marc has been to many of the world's big sports spots, he told me he'd still like to go to Algeria, saying "I've seen a few images from the deserts that look very intriguing."

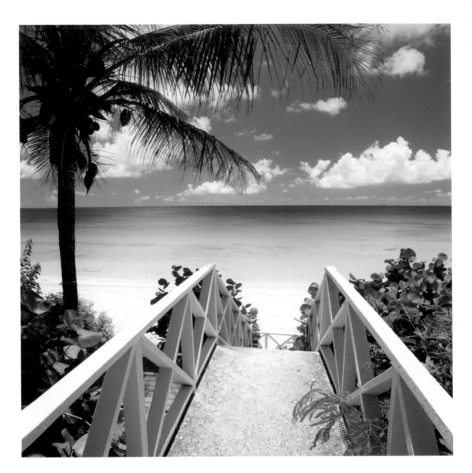

Don't Stage

Like many travel photographers, when he's in a natural setting, Marc tries to get the photograph he wants without staging it.

In natural settings such as Africa, I try to capture uninterrupted scenes where I haven't staged anything. Of course if I'm working with people as models, I become the director as well. I've worked with many art directors out in some wild places. They usually feel out of their comfort zone and rely on my direction.

My approach is usually to photograph people hiking, climbing, or skiing. In those situations, I have a conversation with them regarding my intentions of making natural-looking imagery.

I have them seek routes or ski lines or particular trails they like, then I attempt to place myself in position for the best camera angle that conveys the mystery, action, or mood of the location best.

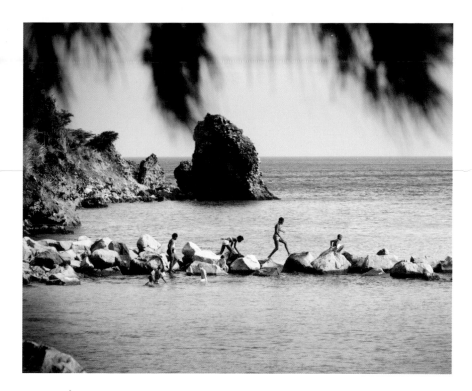

Marc's Photo Tips

1. I like to photograph landscapes and people in natural light—and that's made me a farmer. I watch the weather all the time!

2. I've been told by many different people at different times in different places that I'm very "lucky" as a photographer. I'm the only one who knows that luck is only that I have simply done my job, been prepared, and been observant of the situations that led me to take photographs. You'll be lucky, too, if you follow the same simple process.

3. With this in mind, the best tip I can share with you is "situational awareness." This will give you the ability to predict what is about to occur. For instance, I use this all the time in landscape and skiing photography where I place myself in the right position just prior to a storm.

I scout where I should be, and then when the storm clears I'm in position and ready to capture the great "after a storm" light.

4. I like really wide lenses for my camera. The only way to make an exciting image with really wide lenses is to get real close to the subject. In most cases, I mean several feet!

Visit Marc's website at
www.muenchphotography.com.

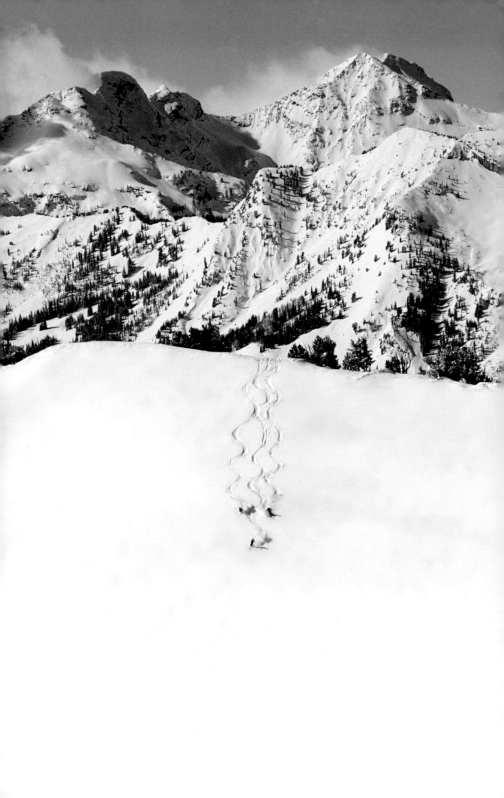

Enjoying the Book?

At NYIP, we know that a passion for photography is something many people share. That's why we published this book, and it's why we are dedicated to providing the highest quality home-study photo education in the world. We want anyone, no matter where they live, to be able to follow their dreams in photography and get the training they deserve.

If you're ready to take the next step, learn to become a better photographer, and even start earning money with your photography, then we're ready to show you the way.

Visit us online at www.nyip.com/book to request a free course catalog.

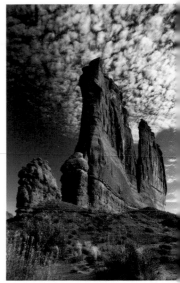

Photo © NYIP Student Jerry Rusk

We promise to make you a better photographer!

"I highly recommend this course to anyone, even those who may be somewhat versed in the basics of digital photography. The audio and video presentations provided by the staff made the instruction more personal and made it feel like they were right in the room with you. Overall this course improved my picture taking, thank you NYIP!" **– William H., Indiana – 2010 NYIP Graduate**

Photo © NYIP Student Michele Goulart

AMERICA'S OLDEST AND LARGEST PHOTOGRAPHY SCHOOL

Photo © NYIP Student John Kerkacharian

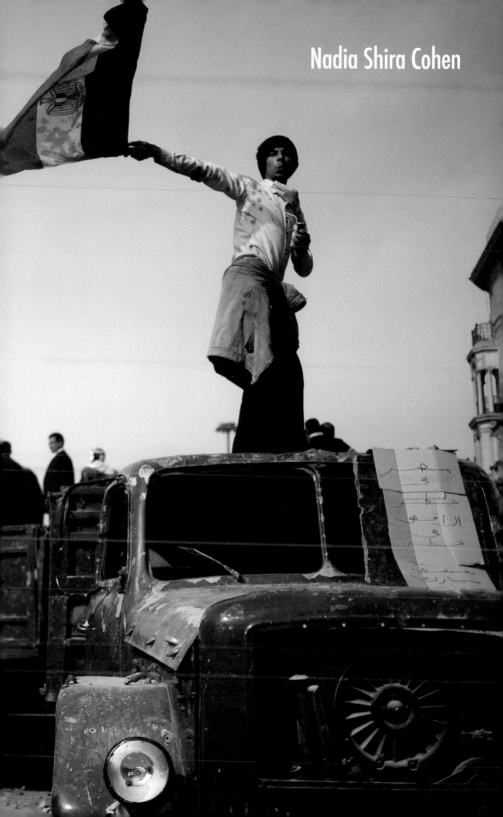

Nadia Shira Cohen

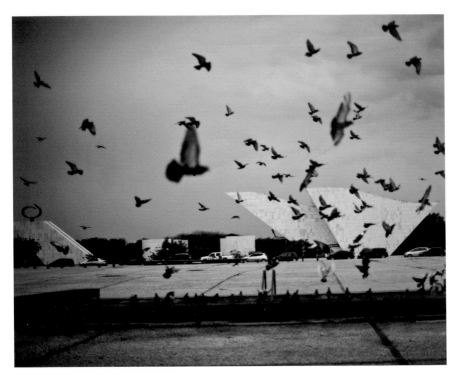

Keep It Candid

Sometimes our lives can change in a matter of days—or even minutes. For Nadia Shira Cohen, the course of her life was changed in a twelve-hour exercise in a photography class, though at the time she wasn't aware that this half day would make her fall irrevocably in love with photography.

Once you have your composition on the frame, sit and wait for things to happen within that composition.

Visit Nadia's website at *www.nadiashiracohen.com*.

Granted, Nadia first got the photography bug when she was just 15 and took a high school class in black-and-white photography that included darkroom developing. But it wasn't until after college when she moved to New York City and was working for theater photographers that she signed up for a night class in photojournalism at the International Center for Photography.

Sit Still and Settle In

Her first assignment was to stand on her city block, without leaving for 12 hours, and just keep taking photographs. Perhaps the task was created to weed out anyone who wouldn't have the stamina.

I began the day timidly drinking several coffees in a Dunkin' Donuts, and finished by dancing salsa—or attempting to— with an old drunk Columbian man in a deli.

Nadia has since moved away from that New York City block, and she's now based in Rome. But she still has the ability to settle in for a long shoot, having spent four months (broken into two trips) working on a story in Rio de Janeiro.

Her ability both to move and to sit still and to keep taking photographs has paid off, and her work has appeared in the *New York Times, Newsweek, Le Monde, New Yorker, Geo Germany, The Independent on Sunday, Telegraph, Vanity Fair Italy, Marie Claire, National Geographic Brazil,* and other publications. It's an impressive list, especially as she's only been photographing professionally since 2004.

Nadia still feels she hasn't traveled enough in Asia, and she'd like to go to Cambodia, in particular, "for its rich history, monuments, culture, and modern cities." And she'd like to go back to Haiti.

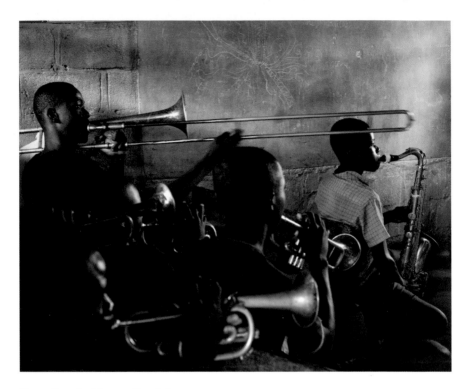

Keep People Photos Candid

People tend to think that travel photographers are most interested in the dramatic landscapes they encounter as they circle the globe, but like many travel photographers, Nadia is mostly interested in photographing people. She prefers "just ordinary people I might not otherwise meet without the excuse of my camera."

To get great photographs of strangers in a foreign land, Nadia relies on her intuition, watching her subjects' reactions carefully, and working slowly.

If I'm walking onto private property or I'm in a more private domain like someone's house, I may ask my subject for permission to photograph first unless it's the type of situation where we've been talking for a while about them and their life and they seem to feel comfortable with me—in which case, I may just start to shoot.

Often, Nadia would rather not ask because it gives the person more of a chance to refuse, and because it often changes their demeanor. The subject becomes more self-conscious. "The photo can lose its candid nature," she said.

But she does get releases signed if she's working on a longer-term project, and certainly with children under legal age.

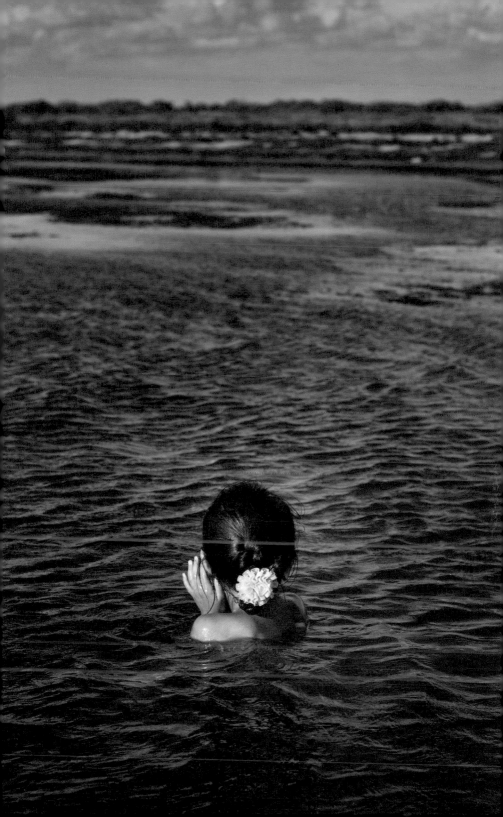

What Works for Nadia

1. If you feel uncomfortable just shooting without consent, ask for permission from your subject. If you get a yes, maybe stick with the stranger for a little while and they'll eventually relax into candid mode and you won't have such a posed picture (if candid is what you're going for).

2. Avoid mid-day lighting for landscapes. It may be a good time to shoot indoors with window light, especially in small stucco houses. Or you could use that time to rest in hot climates and instead get up early to take advantage of beautiful morning light and then later again in the afternoon and evening. I often use the time to talk to my subjects in longer-term projects or lunch with them. That way they're much more comfortable with me when I do decide to begin shooting.

3. Take your time to find the right photographic angle and vantage point. There's no rush. Oftentimes we can feel that the picture needs to happen instantly, but if you take your time and look above, below and around, you may find a much more interesting vantage point to take the same picture from. Your photos will become much more dynamic.

4. Know your rights as a street photographer. Laws vary in every country, but there's usually a lot of information on the Internet about this. Sometimes there may be a way to photograph something restricted from a public space which is often times not illegal. Sometimes talking to authorities and sending a fax for permission ahead of time can help a lot in gaining access to restricted areas. You may get a straight-out rejection and have to weigh the risks of the picture and the possibility of taking it illegally.

5. Photograph architectural details as well as larger-scale landscapes. It's important to give context to structures as well as appreciate the incredible detailed work of the architect.

6. Guides can be a great help and also a great pain in the neck, depending very much on their personality. You may find that they try to guide you too much and aren't flexible. Be firm with them, as you're the one paying for their services,

but also listen to their advice since they're most likely local, speak the language, and are able to navigate the terrain better than you.

Do remember that in some cases your safety is a guide's primary interest, and this may conflict with good light and other photography considerations. Try to speak to your guide and be clear about what you want out of your trip. He may be accustomed to working with a "certain kind" of tourist, and he might be putting you in that category.

7. You'll find brilliant light for photography at sunrise as well as sunset, yet when you venture out to take picture, pay attention to the very different paces of life (morning versus nighttime). Depending on where you travel, the flow could be more chaotic or sleepy at either time. Returning to a scene you'd like to shoot at a different time of day can also give you a different position of the sun; for example, if you want to photograph a specific monument but it's always backlit when you arrive in the afternoon, try returning in the morning when it's being illuminated by the sun.

8. We photographers can't control the weather, so we must learn to work with varying conditions and be flexible. Don't let a rainy day get you down or keep you inside! Rainy days can sometimes provide the most amazing light, which shines through pockets of clouds in more tropical climates as rainstorms pass through. Use the weather to your advantage. Try not to fight it, and use your bad-weather time to do indoor things, as well as waiting for those special moments of light. Also search for rainbows!

9. You really only need simple tools as a travel photographer. A camera, a tripod, and a reflector should do it. I personally don't travel with much else unless I'm shooting video with my 5D (the Canon EOS 5D Mark II) or night shots. Reflectors are good for portraiture and can pack away quite small; if taking portraits is one of your travel photography goals, definitely bring a reflector. A light tripod for evening slow-shutter shooting can be quite useful.

10. Always be aware of where your equipment is. Use your street smarts. Don't leave your equipment with anyone you don't know and trust well. Avoid showing a lot of fancy equipment if you can avoid it, however use what you need to take photographs in public areas.

If you're in an area you know to be a high-theft environment, you may be taking a risk and wind up losing your equipment. This is where a guide may come in handy—a trusted person from the area who can watch over you is sometimes enough to keep you safe and watch over your possessions.

Be Picky and Patient

Keep working on your composition. Don't just settle for an image of what's in front of you, but work the frame until it's satisfactory to your vision. This may take a couple tries, but don't be afraid to experiment and see what gives you the best results.

Once you have your composition on the frame, sit and wait for things to happen within that composition. You may be pleasantly surprised to find a man walking through your frame with a bundle of balloons or a flock of pigeons scattering or other actions which are photogenic.

11. I find that cooperation and a nice attitude with border security goes a much longer way and gets you through with fewer problems. Cooperate with all security officials. If you feel your equipment is being mishandled, explain this to the officer. If you're passing film through an x-ray scanner, opt for a hand check. Officials may be reluctant and tell you the x-ray is fine, but I've had 400 ISO film ruined in machines before ... and that's why I fight for the hand check (but again, with a nice disposition).

12. Back up and store your images every day—at least once—and if you have enough space, back up your photos in two different locations. I bring a very small, inexpensive external hard drive everywhere. If you feel yourself in a hostile environment where someone may demand that you delete your photos after taking them, you can avoid this by discretely switching your camera's memory card. Hide the original card with the pictures somewhere else. If you do this, remember to shoot something on the new card you've inserted to make the process go smoothly if you are indeed confronted by someone.

Switching memory cards is also recommended if you're in an environment where, for reasons of weather or theft, you feel there's a risk of losing your cards. In this case, you may want to switch out ones that have great pictures on them until you get to a safe spot to download. I usually carry more cards with fewer memory on them for this reason.

13. Filters can be quite fun and easy to use. I find the polarizer interesting as well as neutral density filters which can allow you to slow down your shutter speed quite a bit in daylight hours and shoot things such as bodies of water in interesting ways.

14. Before taking a specific photograph, try to get your head out of the cliché. You may be presented with an image you've seen many times before, and it's natural to want to shoot it in the way you know or have seen it in print. Instead of shooting what's customary and familiar, wait a bit and look for a detail in the scene that can be not so obvious. Experiment!

Don't Be a Hero

Remember that no photo is worth risking your life. Extreme weather can sometimes be quite photogenic, however you must take precautions.

When venturing out to shoot, use your intuition and speak to locals who may be more accustomed to extreme weather conditions.

Be prepared to take shelter, if necessary. Outdoors, a mild situation can turn dire in a matter of seconds.

If you're dealing with extreme cold and heat, remember to take care of yourself and dress properly. Heatstroke and hypothermia can be very serious conditions.

Don't put a damper on your entire trip by pushing yourself too hard. No photo opportunity is worth sacrificing your health and safety.

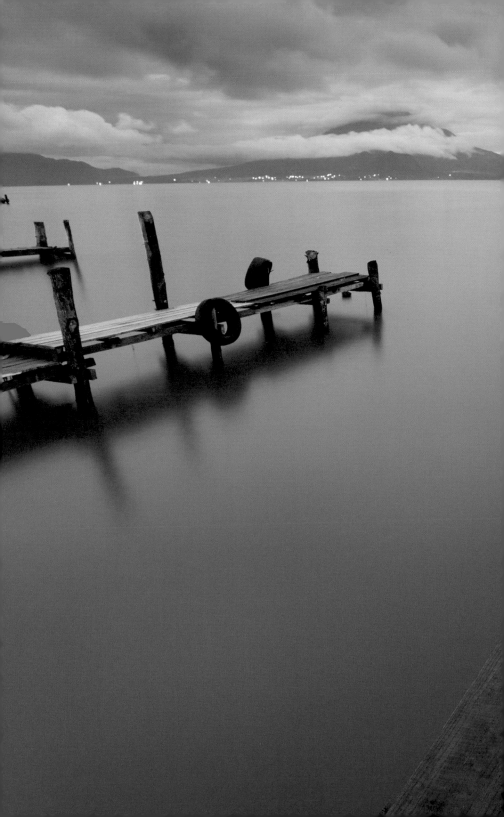

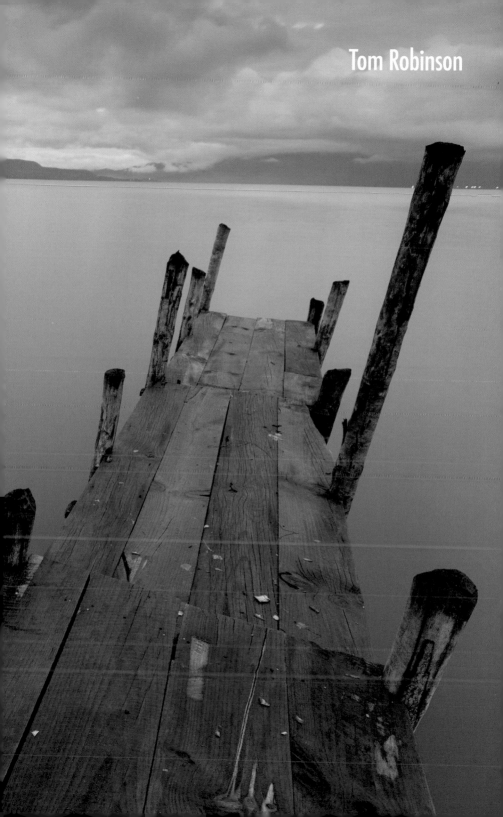

Tom Robinson

Combine Geek and Artist

I always like to hear how photography professionals first became interested in the craft. Talking with British photographer Tom Robinson, I learned that he first became interested in photography when he was in high school and bought an Olympus OM-1.

I think the perfect travel photographer is a balance between an artist who can make the ordinary look beautiful and a geek who understands a camera and all its settings.

I spent many hours in the school darkroom exploring all sorts of techniques. It was definitely in that small darkroom that I became hooked on photography. These days, convenience has won me over and I now use a digital camera, but film definitely helped me fall in love with photography.

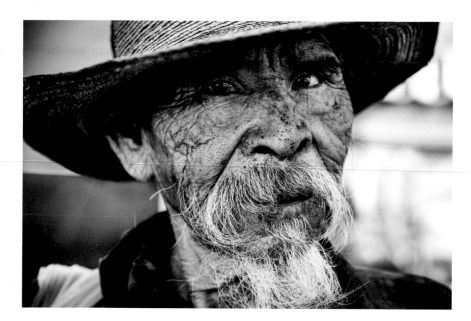

Another People Person

As I interviewed the travel photographers for this book, I started to see a theme emerge: most travel pros stress the importance of photographing people rather than places. So it wasn't surprising when Tom told me that he's most interested in photographing people in foreign lands.

Seeing how people in different environments and cultures go about their everyday lives has always been a highlight for me to photograph.

Going to famous landmarks or museums is okay, but give me a bustling market or a small village and I can spend hours just roaming the streets looking for people and things to photograph.

And not only hours. Tom once spent five months meandering through South America, traveling by every conveyance possible: bus, lorry, scooter, bike, pickup truck, row boat, ferry, and donkey. "It was an incredible trip," he said. "South America is an amazing continent with such a diverse mixture of landscapes and cultures."

But Tom's also very aware that there's more out there waiting for him to focus on it. In particular, he'd like to visit China, Mongolia, and Nepal.

I love countries where traditional dress is still commonly worn. And I'd love to go into the mountainous regions and photograph how people live their lives in such challenging environments.

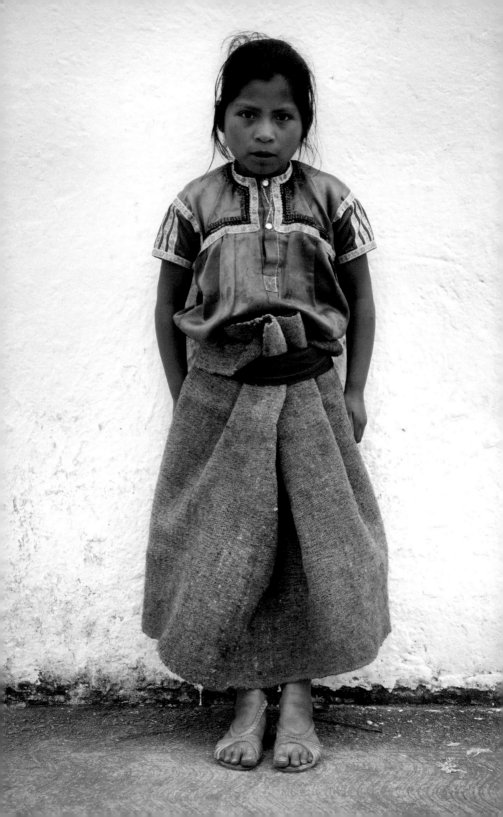

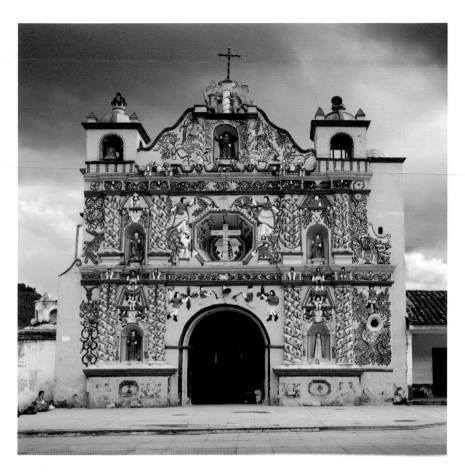

Get Permission

When he photographs people, Tom simply asks if he can take a picture—but he asks permission with his camera pointing to the floor, and he always asks with a smile on his face.

If they say yes, I take my time and snap a few frames. If they say no, I give an accepting nod, say thank you, and walk away. The key thing is to be confident and friendly, accept that a lot of people will say no, and when someone does say yes, you take your time, make sure you've got the right camera settings, and thank them afterwards.

Tom doesn't always get releases signed. "Many people, when presented with a release form, haven't got a clue what it means, even when you explain it. Releases are necessary, but very annoying," he said.

The big exception: many of Tom's professional travel photography jobs will require a release, in which case Tom makes sure it's written in the language of the country he's in.

Tom's Tips

1. When photographing strangers, I never tell them how to pose. In my experience, when you tell them to stand in a certain way, it instantly looks unnatural and posed, resulting in an awkward-looking photo.

2. Asking a complete stranger for a photo is a difficult thing to do, but as with all things, practice makes perfect. To begin, think about how you would like to be approached by someone wanting a photo. What would you like them to say, or more importantly not say. And if you don't speak the language, you'll be surprised at how far a smile can get you (well, sometimes).

3. I've lost count of the amount of times I've been in an incredible place, or seen a really striking person, but the light just wasn't right for a good quality photo. The key is to learn what light delivers the right results. For example, on a recent trip to Morocco, the sun was extremely bright, but I concentrated on shadowy areas created by the buildings to get some great portraits.

 There's no easy way to avoid the too-bright midday lighting, but you can use this time to scout locations so that when sunset or sunrise comes, you're going to be ready and you'll be in the right location.

4. I have hundreds of photos that would be great if "that person wasn't in the background" or "that person wasn't wearing that pair of shoes," etc. Sometimes Photoshop image editing will save the day, but sometimes it won't. The key is to be aware of every single element that's in your viewfinder and how they all need to complement each other to make a great shot.

5. Here are some of my photography habits. Maybe they'll inspire you, maybe not.

 - I very rarely crop photos.

 - I love horizontal lines in photos, such as horizon lines, buildings, etc.

 - I like composing photos with a lot of sky and a bit of ground (or vice versa).

 - I rarely use a flash.

 - I often underexpose my pictures by $1/3$ or $2/3$ of a stop to preserve highlights. (Check your camera's instruction manual for specific information on how to do this.)

What Is Travel Photography?

Creativity plays an important part in travel photography.

I think the perfect travel photographer is a balance between a geek who understands all the camera functions and an artist who can make things look beautiful.

Inspiration is really important, and I often spend hours looking through books, magazines, and the Internet, trying to get new ideas for great travel photos.

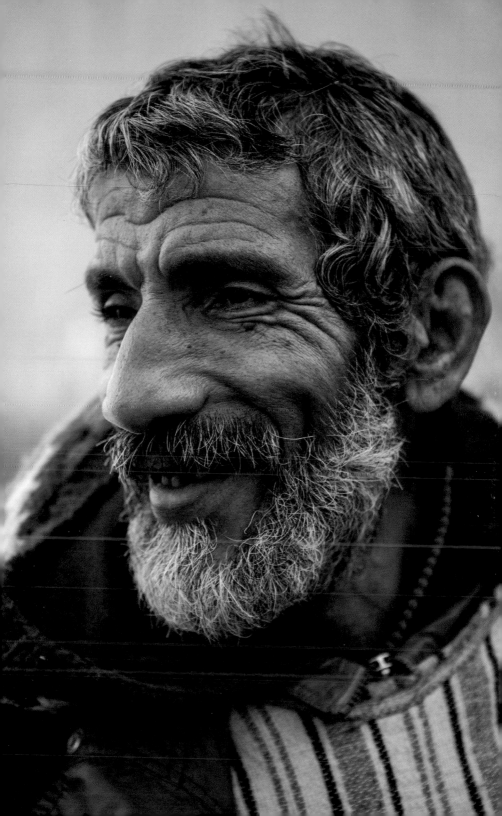

6. Feeling adventurous (but never foolhardy)? Gaining access to restricted areas to take photographs is about knowing the right person, and that person isn't always the one at the top. It quite often pays to talk to the people lower down the food chain like cleaners and security guards.

7. Just as I know all the best spots near where I live, local guides (or fixers) can be extremely useful in finding interesting and different locations for you to photograph. And they don't have to be "official" guides—hotel staff or shop owners, for example, should be able to tell you what you're looking for.

8. Try to make the most of bad weather in your photography. Fog, rain, and snow can all be photographed in an interesting way. You just have to be creative enough to see it.

9. I have a love/hate relationship with tripods. They're heavy, cumbersome, and slow me down a lot. But they're completely necessary to get some shots—balancing your camera on a rock or fence will only get you so far! A reflector is great if you have someone to hold it, otherwise I think it just gets in the way and your subject will just think it's weird.

10. Over the years, I've met a lot of other people who had their cameras stolen, but when I've asked further questions, they'd always done something stupid like leaving their bag unattended or forgetting it on the back of a chair while they were lunching in a cafe.

11. If you've done a fair bit of traveling, I think you soon build up a natural awareness of what's a safe and unsafe environment. A lot of the time I walk around with my camera around my neck, and I've never encountered any problems. But there were times I'd definitely stop and put my camera back in its bag, away from prying eyes.

12. The only filter I use with my camera is a circular polarizing filter. It's great for darkening blue skies. I've tried using other filters but I don't like how they slow me down.

13. During long trips, one of the biggest logistical problems is backing up my photos. I don't like taking a laptop with me, so I often opt for two portable hard drives. I keep the two drives mirrored: one lives in my big rucksack while the other hangs out in my day bag. Both are stored in padded camera cases and Ortlieb waterproof cases (www.ortliebusa.com).

Best Tip of All

The most important tip in travel photography is to really open your eyes and look for a subject and angle that will tell a story and make an interesting photo.

I constantly keep pushing myself to re-look at the environment I'm in and try to interpret it in a different way. I'm a strong believer in the idea that the more shots you take, the better you become—so you've just got to keep pushing yourself and try new things with your camera.

Visit Tom's website at www.tomrobinsonphotography.com.

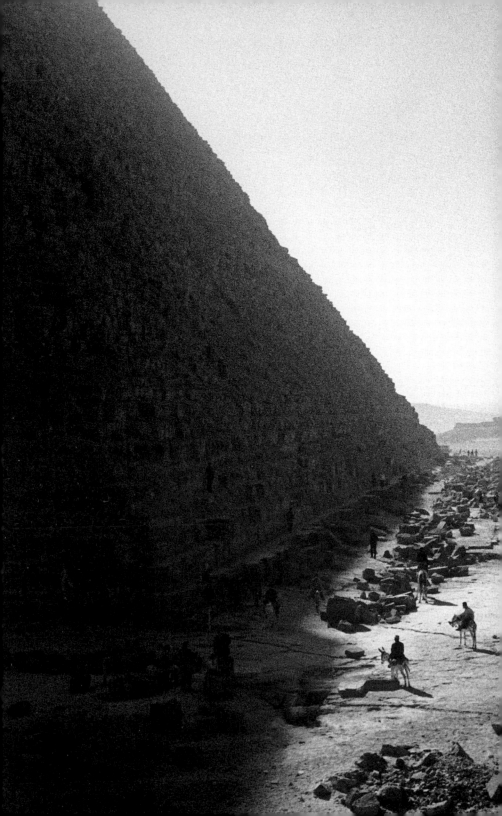

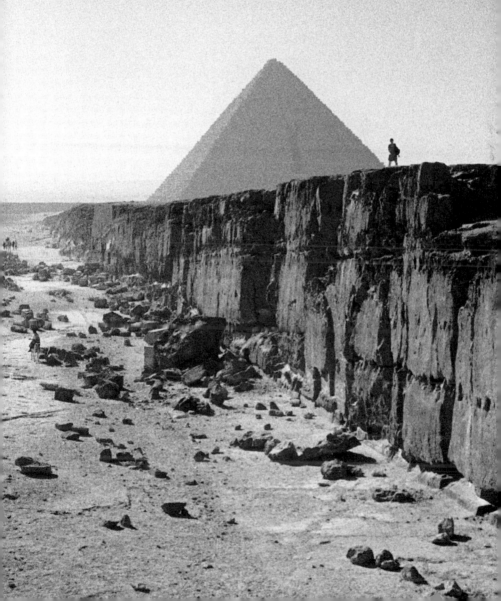

Jesse Kalisher

Channel Your Zen

In talking with all the successful travel photographers for this book, I've found that the creative impulse can be encouraged or discouraged. In many people, that spark will burst into flame ... no matter what.

Rid yourself of all the things that are on your mind—how badly you want the picture—and just be a human being.

For Jesse Kalisher, growing up with a photographer father was fascinating, and it may have influenced his career choice. But Jesse was primarily raised by his mother, and saw his father only every other weekend. When Jesse hit his teen years, his dad took him on school vacations as his photography assistant.

I realized he was on top of his game, working just 30 to 60 days out of the year to earn what he needed. I used to marvel that he got paid so much just to take a picture.

Despite his interest, Jesse said his father dissuaded him from becoming a photographer, with "selective use of praise and criticism." Jesse went off to college to pursue a degree in economics, and worked in the advertising business in New York City for years after college.

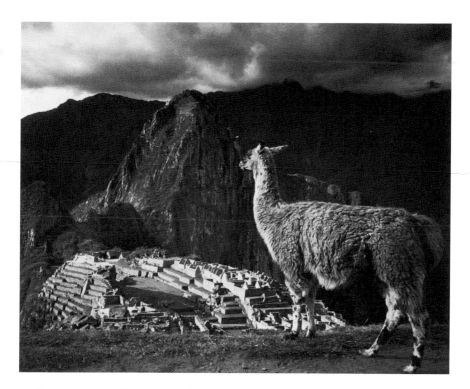

Embrace Travel's Allure

Later, when Jesse moved to San Francisco, he said he was very successful "but spiritually unfulfilled." After creating national ad campaigns for major Fortune 100 companies, with no mortgage or kids, one day when he was 32 years old he just gave nine months' notice at his corporate job "and I was done."

My life had become a series of boxes: the office, the home I lived in, the car I drove to work in, and none of it inspired me. None of it.

Some people, notably a former boss, thought he was nuts to leave his lucrative profession. That same boss called Jesse a couple of years ago to say he'd been wrong.

What I realized was that as a young man, I'd always been keen on being adventurous. I had that desire to explore. I realized I had totally lost that. I translated that to traveling.

Jesse started by going to Vietnam.

The United States was reshaped by the war in Vietnam. I had read a lot about the Vietnam War, and when I realized I needed to change my life, I wanted to rediscover the inner explorer and go traveling.

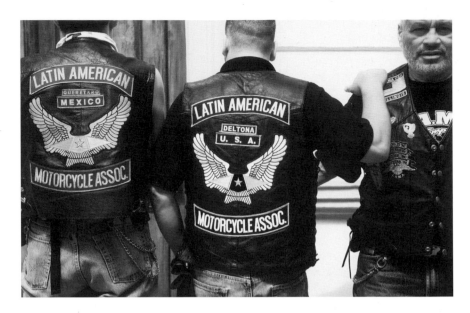

Frame Your Pictures

Although Jesse set out to travel, he didn't set out with the idea of becoming a travel photographer. He took off by himself, and he brought along a "snapshot camera."

But when he got to Hanoi, he saw a scene begging to be photographed: the sun peeking over the horizon and a few kids setting up their bicycles on either end of the street to create an area to play badminton.

I just started taking pictures—a snapshot here and there. But as I brought the camera to my eye to take a snapshot, I started framing a picture. Instead of taking a memory, I started looking for something with meaning. And it was an epiphany.

It was a remarkable moment because in that instant, Jesse went from being a wandering tourist to being a photographer. As soon as he brought the camera to his eye, he said, he felt "Oh … I remember this." But the mystery is why this happened in Vietnam and not before that trip.

I remember trying to tell a story and working the corners and finding the angles and looking for the best possible shot. All the years that I'd been playing with a snapshot camera, roaming around northern California or the Grand Canyon, it didn't happen. I was just taking snapshots. In Vietnam, that didn't happen. I went to take a snapshot and I wound up taking pictures.

Tell a Story

What makes a picture great is when it's both aesthetically pleasing and tells a great story. For Jesse, that's an important distinction.

A great picture is one where we don't know if we like it better because of the aesthetics or the content. When you look at a picture that's pretty and it tells a story and those two things are fighting equally for your attention, then I think you have a great image.

And he knows when he's in the process of taking a photograph, whether it's a great shot or not.

I know when I'm a taking a picture, and it's just a pretty picture but it has no story. And sometimes I'm taking a picture and it has a story, but I don't quite have the aesthetics down. And sometimes I'm taking a picture that's got both—and it's a home run!

Listen with Your Eyes

Jesse travels the world taking home-run photographs. Two of his favorite places to travel are Ethiopia and Egypt. He finds that what makes a trip successful is a combination of being humble and "actively listening with our eyes."

Active listening with our eyes is seeing what's happening around you but also understanding the subtext, understanding the story of what's happening. As with many of the photographers I interviewed, Jesse feels that the real heart of a photograph is in the people who are in the composition.

For me a successful trip is one where I'm able to take the time and emotional energy to pay attention to what's happening around me. So I'm not just in Agra to see this building called the Taj Mahal. While I'm there, I notice the people working and the life on the street and the dichotomy of the guy hauling some stuff on his back or on a camel—all of this is going on in front of the Taj Mahal.

Say It: "I'm a Photographer!"

It used to be that I'd pull out my camera and people would be impressed—but now everybody's camera looks like mine. Now everyone has a DSLR. This creates a bit of a challenge because people who were willing to give you access because you were a serious photographer may not be so keen now.

But on the other hand, I'm no longer standing out as the guy with a fancy camera. Also, I'm thrilled that so many people are getting involved with photography. This is the golden age, where the barriers to access have been removed, and so many people can explore their passion for the media.

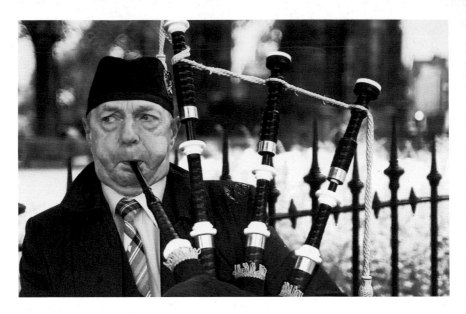

See Things Independently

Jesse always travels with his wife Helen—they originally met at the Mayan ruins of Tikal in Guatemala—and yet he knows there's a risk of becoming complacent when traveling tandem. To illustrate this, he told me a story. Once he was in a hot air balloon and, afraid of heights, he focused on the rope three feet in front of his face that ran from the basket to the balloon.

The risk is that the person you're traveling with becomes that rope, and then we don't see everything else that's going on. The challenge is to make sure you're always seeing beyond that.

One thing Jesse has learned in his travels is that everyone sees things differently, and he's determined to keep his eyes open to as much as he can.

One day, when he was just starting out, he was traveling with others in Ethiopia, and every day they drove past different women carrying bundles of sticks on their backs. Jesse started wondering about them, and suggested one day that they stop and get a photo.

The people he was traveling with said, "What are you talking about?" They hadn't seen the women carrying the sticks on their backs.

You have to get outside of yourself, and get past your comfort zone, a person, your family, or the group you're traveling with—anyone who's the equivalent of that rope on the balloon for you. But you also have to respect the fact that we're all seeing different things.

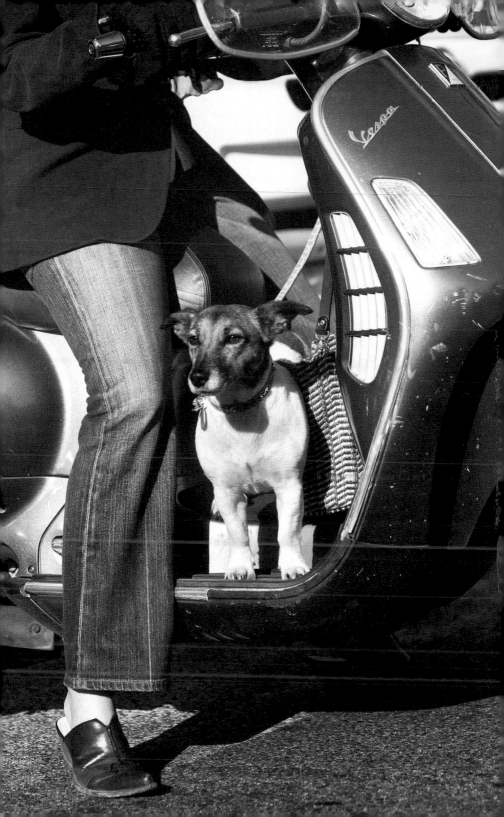

Carry Business Cards

In addition to needing that ability to look beyond yourself, you also need some equipment. Currently, Jesse carries about 30 pounds of equipment, including a Nikon D3X, a full range of 2.8 zoom lenses, from 14mm up to 200mm, a 105 macro, a Lowepro nature trekker he can carry onto a plane, and Lexar professional media cards.

Jesse also carries business cards just in case he needs them. One occasion was when he was in Edinborough, Scotland, shortly after the Glasgow airport bombing. He was taking pictures of the Edinborough castle at night with a tripod, and having a business card as a way of explaining himself to authorities was enormously helpful.

Approach People Calmly

Jesse finds the best way to approach people he wants to photograph is by being at peace with himself, and being respectful. It's almost a Zen state of mind.

Rid yourself of all the things that are on your mind—how badly you want the picture—and just be a human being. If you're one human being letting another human being know that you respect him and you'd like to take his picture, I find that to be successful.

This attitude paid off when he spoke to a police chief about getting a picture of a Buddha inside of a police department in Thailand.

I really wanted the picture but I knew I just needed to be relaxed, focused, real, and present. When the chief showed up, it was clear I wasn't a priority; I was a distraction. I explained what I was doing, and he looked me in the eyes and said, "You're very at peace. You're a very lucky man. Go ahead and take your picture." It's that spirit we need to channel when we want to take somebody's picture.

Option: Travel Unplugged

One of his most recent trips featured Jesse unplugged: a vacation in Nicaragua with his wife and kids. Jesse left his cameras at home.

I wanted a vacation. I was perfectly content to have a vacation, which meant no email, no phone calls, no Internet, and no cameras.

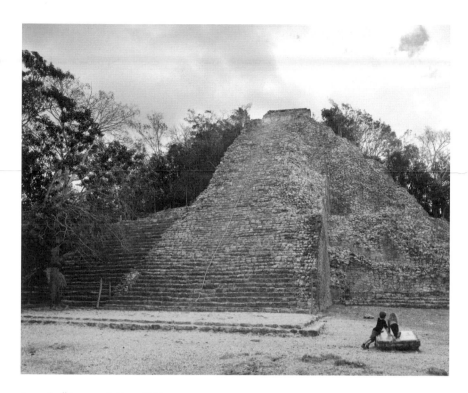

Jesse's "Fantastic Four" Tips

1. Be respectful of people. Some tourists see kids begging, a homeless person, or a drug addict on the street and think that because they have a camera they can just take the picture. If you're a photojournalist, this is your job, so fair enough. But most of us aren't photojournalists. I, for one, don't want to build my reputation on the misfortune of others.

2. Look for what interests you, whether it's shape, geometry, or story. Look for ways to tell a story.

3. Shoot a lot and edit mercilessly.

4. Look behind you. Sometimes the best photo is behind you.

Visit Jesse's website at *www.kalisher.com* and his blog at *www.kalisher.com/photo_blog.*

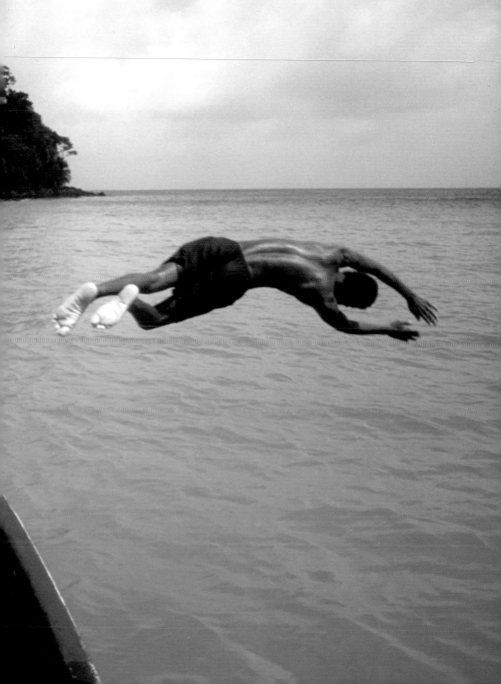

Peter Guttman

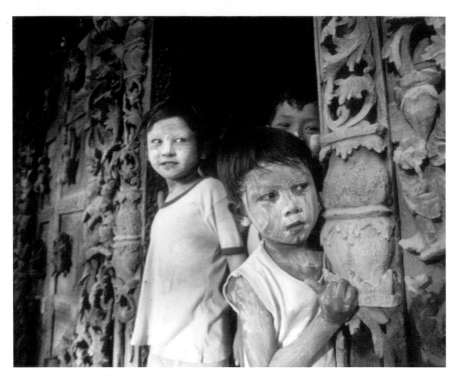

Photograph Intrigue and Wonder

Manhattan photographer Peter Guttman sets the bar high for all other travel photographers, being a two-time recipient of the Gold Medal Lowell Thomas Award for Travel Journalist of the Year.

In travel photography, an exaggeration of drama, lighting, and atmosphere are key components.

He's been published in numerous books and magazines, including *Condé Nast Traveler* and *National Geographic Publications,* he's the author of five hardcover travel books—including Fodors' first hardcover book series, and he provided all the images for a Calvin Klein calendar (in their first-ever travel campaign for the aptly named scent "Escape").

He's traveled on assignment to all seven continents and 210 countries.

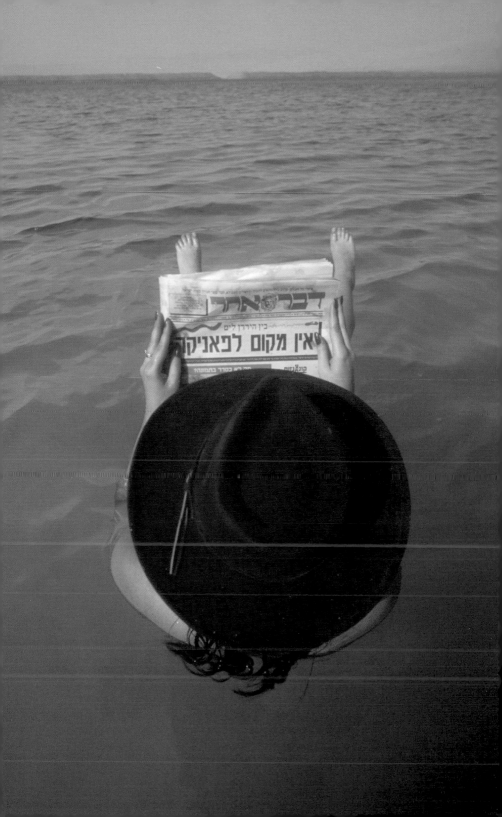

Add Art to Your Family Life

I don't care if it's via nature or nurture—it's just a pleasure to see a passion for a creative art being handed down to the next generation. Peter told me that his father Arthur passed down the DNA for artistry—he'd gone to New York City's High School of Music and Art, and then Cooper Union. Even though he wasn't able to make a living as a painter, he did instill in Peter a love of drawing, making sure he had paper and pencils and crayons to play with.

At the age of five, I had a little drawing of mine that was exhibited in the Lever House on Park Avenue. I got the art bug, and that morphed into an interest in a school of art called magic realism, which was a style of painting in the 1950s and 60s, eerie realistic depictions of everyday life.

In college, Peter devoted a lot of his time to art, but was reluctant to sell his artwork, so he looked for a way to express himself artistically and make a living—and he hit upon photography.

At first I was kind of ashamed of myself. I thought, well, no one can draw and paint like I can, but anyone can just snap a shutter and get these pictures, and I didn't feel as proud or impressed with my artistic talents.

But he kept taking pictures, and because he didn't want to "go down a narrow tunnel," Peter majored in geography, and that led him to become a tour guide.

I brought my trusty camera with me, and during that time I amassed quite a collection of images, and soon started bringing them to magazine editors, who were very encouraging. It was when I was traveling at a frenetic pace, and my tour guiding had expanded to leading special interest groups around the planet, like Harvard Alumni Association or National Audubon Society members. So now I was really getting incredible images from around the planet.

Look for the Unusual

Peter likes to seek out the unusual in his travels, and that comes through in his photography. He describes the process behind his assignment work for Fodor's.

I like to go way off the beaten path, leading me to places to sleep that might be a treehouse or an underwater hotel that you have to scuba dive down to.

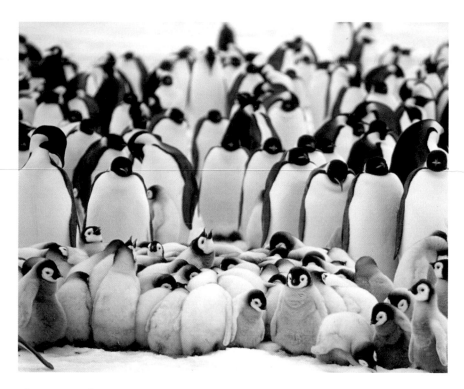

Share Your Photos

Eventually one of his photographs was published, then another, and soon Peter started producing slideshows in his living room. His presentations began with twelve people, and grew to a remarkable 70 people at a time. (The record was 93 for a single holiday season show!) People came to see the photographs he took on his world travels, and now these shows have been a Guttman family tradition for 26 years.

I suppose it's just inherent in my personality, but I've always been extremely interested in inspiring others. As a tour guide, the juice that motivated me was to help people open their eyes to see the beauty of the world around them. As we go through about 1,200 photographs at about 4 or 5 seconds per image in a slideshow, I'm able to share an incredible authenticity and intimacy with others that they can't get from TV or Internet entertainment.

Peter's wife, Lori Greene, provided the music for the slideshow background, and his son Chase Guttman did the sound effects (see Chase's travel photography starting on page 42). The show became so popular that it was named one of the hottest tickets in New York City by National Public Radio.

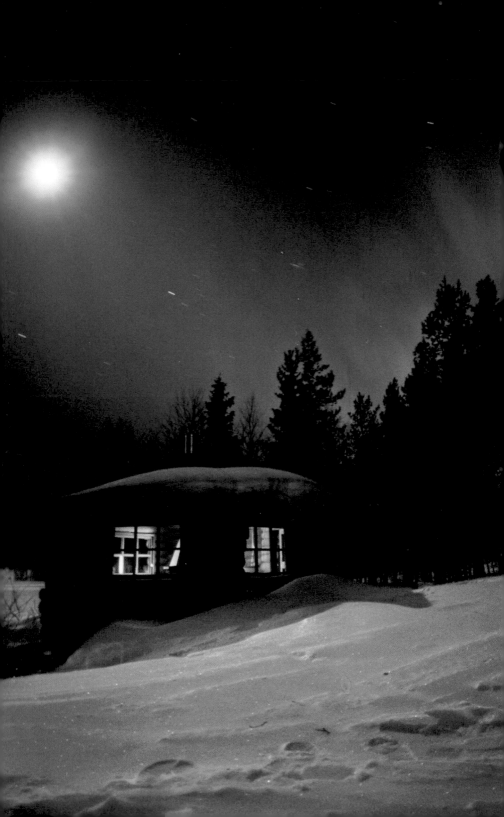

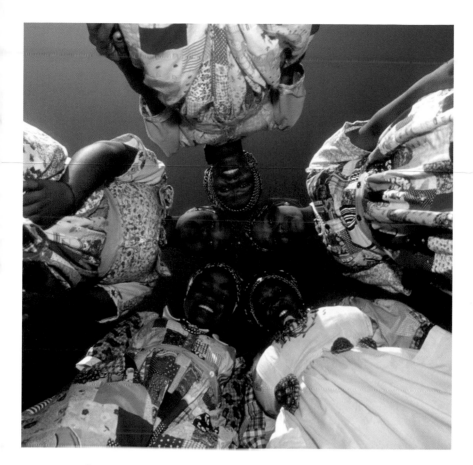

Try Using Film

Something that sets Peter apart from many photographers is that he shoots exclusively in film, because he finds it more beautiful.

There's a visual richness and depth that you can get on film that you can't quite capture in pixels. There's a difference between the dot that's a pixel and the blending together of grains, and it's very subtle.

Peter says that no one switches to digital because it's more beautiful; it's more economical or more convenient,

but it isn't more beautiful. As someone who went into photography in order to be an artist, he feels film is his medium—and he's not switching to the newer capture technology.

But despite his aversion to digital, Peter leads the world of photography apps. He created the #1 best-selling travel app for the iPad, Beautiful Planet HD, and four other travel photography apps. Visit *www.peterguttman.com* for more information.

Equip Yourself

Be Flexible

For Peter, it's important to consider how a given situation demands a particular approach to taking travel photographs of complete strangers.

Sometimes it's better to be a fly on a wall where you can take intimate images where people aren't even aware that you're there. Other times, it's really helpful to have the knowledge and cooperation of other people.

When it comes to the equipment he uses, Peter is serious about quality. Peter started on a Nikkormat, which his grandmother gave him for his 17th birthday. He later moved on to the F2, and then eventually to the Nikon N90 and 90S.

Peter travels with two camera bodies, or if he's feeling like living dangerously, he'll just carry one. He generally doesn't need anything closer than a 200mm lens, he uses no reflectors, and he has no other fancy accoutrements, except for a tripod.

The most essential tools that you need are your brain and your eyeballs. And that will more than compensate for a lack of perfect equipment.

Peter's Top Tips

1. Be able to identify what it is that excites you. Before you book your trip, find those regions of the world that stir your blood.

2. Analyze a scene and figure out what motivates you to capture that scene, and then try to emphasize those elements.

3. Patience is a key ingredient to being a good travel photographer. You need to have an even temperament and take your time.

 Visit Peter's website at *www.peterguttman.com.*

4. Figure out what the purpose of an image is— before you take it!

5. The best photographs come from an insight that this lighting, this angle brings the moment alive.

6. In travel photography, an exaggeration of drama, lighting, and atmosphere are key components. They're ways to spark a sense of wonder. Look for intrigue and wonder in the scenes you want to photograph.

7. If you're trying to capture something in motion, even with the simplest camera, follow the object in motion with your body and camera while you're snapping the image. You're freezing the image as it's moving, but the background relative to you is moving at a different speed, so you can capture the feeling of speed and exhilaration.

8. Give yourself "spiritual permission" in your own head to get close and not see things in a timid manner when you're on the road. You need to give yourself a pep talk and not look at your trip from the passive perspective of a tourist. You're an active, involved, and engaged traveler.

Index